Women See Men

Yvonne Kalmus

Rikki Ripp

Cheryl Wiesenfeld

editors

introduction and text by

Ingrid Bengis

art direction by

Geri Davis

McGraw-Hill Book Company

New York St. Louis San Francisco Toronto
Sydney Düsseldorf Mexico Panama

During the course of this project many people were generous in their support and assistance. We would especially like to thank Ginger Barber, Peggy Tsukahira, Donal Holway and Kit Kuperman. Grateful acknowledgement is also made to the hundreds of women photographers whose enthusiasm and trust made this book possible.

The Editors,
WOMEN SEE MEN

The following photographs have been copyrighted and appear herein with permission:

Page			
11	Dena	75	Sherry Solomon
34-35	Gretchen Berg	82	Marjorie Pickens
36	Sonia Katchian	85	Barbara Morgan
60	Lida Moser	102	Carol Wald
61	Barbara Morgan	103	Carol Wald
72	Suzanne Opton	107	Dena
		110	Lida Moser

1234567890RAHO783210987

Library of Congress Cataloging in Publication Data
Main entry under title:
Women see men.
1. Men—Portraits. 2. Women photographers.
I. Kalmus, Yvonne. II. Ripp, Rikki. III. Wiesenfeld, Cheryl.
IV. Bengis, Ingrid.
TR681.M4W65 779'.23'0922 77-8860
ISBN 0-07-033248-7
ISBN 0-07-033249-5 pbk.

Introduction

Once, when I was speaking at the University of Pittsburgh, a young man came up to me after the discussion and said, "Women always want us to understand them, to be more open about our feelings, to let them know what's on our minds. They want us to say everything. Why can't they accept us the way we are? We don't need to show our feelings all of the time, or constantly prove that we care. I do care. Why isn't that enough?"

I thought of that boy while looking at these photographs. As a woman I am constantly on the lookout for those feelings which usually lurk beneath the surface: the capacity for intimacy, for a sense of unexpected outrage, for aspiration and despair, for anxiety and frustration and bewilderment and hope, for the fugitive moment of openness to experience. A photograph, while inevitably attempting to capture those layers of the mind which know of only momentary expression, is hampered by its literalness. It cannot be hypothetical, cannot take a feeling on faith. It cannot make visible what is invisible. In that sense, the camera is like a woman looking for the proof of feeling from a man; no matter how much she scans his face for evidence, she must frequently settle for what she can glean by implication rather than direct knowledge. She must believe in what she cannot see.

The challenge of making the effort to "see" men is that they have the habit of concealment, of a reserve so profound that it scarcely leaves any suspicious traces. A woman's face in repose tends to be expressive of some element of her inner life, which she might not consciously choose to reveal otherwise. Walking down a street, one can know something about what the women are like just by looking at their faces; the men are much less distinguishable, one from the other. "Having an expression" is a woman's silent act of faith, just as "doing something" is a man's. Men reveal themselves cumulatively by the slow accretions of their actions. A woman wishing to know a man must look for those telltale signs of behavior which, over a period of time, add up to a feeling, since she cannot always find the feeling itself. This is a little bit like knowing about the presence of an animal in the garden from the systematic disappearance of certain leaves on certain trees, even though the animal itself has never been seen.

Recent changes in masculine fashion from uniformity to variety have made the unicorn a little bit less elusive. In the drive for "self-expression" a man can select a number of "looks" which appeal to him: the "banker", the "swinger", the "continental charmer", the "rugged sportsman". These "looks" may have very little to do with his real inner character. They may be just another disguise. But even this small act of daring makes men feel that they are living dangerously. What they do not know is that their costumes reveal their fantasies about themselves in a way that women's clothing (more closely linked to currents of style) rarely does. This single fact makes their selections, which might otherwise seem ludicrous, immensely touching. Similarly, if a man of fifty allows his hair to curl at the nape of his neck and around his ears, combing a few strands across a bald spot, he is making a far more dramatic statement than a woman who goes out and changes her hairdo.

In Japanese, there is a word which has no English equivalent. It means "the space between," what happens when nothing is happening, or what exists in the interstices between two realities. It is interesting that while men are creating materials to fill up space, creating concrete objects, their real existence goes on in a space which is invisible. It is often possible to see that they suffer from the inability to find a form of expression which would match their feelings, as if they could not make real to others (particularly women) the palpable truth of what they feel and know and see, of their needs and fears and expectations, their dreams and nightmares. Men's understanding of each other is predicated upon an acceptance of this difficulty: men do not ask other men to "express themselves." Their camaraderie is based on the empathetic knowledge of the impossibility of expressiveness.

And yet, among women, the longing to see a man's insides, to see what, beyond intellect and action, stirs his being, persists. We scour about for evidence. We talk about men in the hope that, even without their cooperation, our shared efforts to see them in absentia will yield up some greater knowledge. We photograph them, hoping that what is peripheral will yield to what is essential. Sometimes we give up, surrender the desire for what is elusive, and settle for the familiar images they offer, the secure, well-known images. It is so much easier, of course, than taking the risk, and finding after a long search that what we see is not what we want.

Perhaps that too impedes the effort, holding us back. After so many generations of not seeing, do we really want to know? Or is it like a love affair which lasts because of the obstacles to its fulfillment, and collapses the instant it has the possibility of realization? If we could see, would we?

April 9, 1977

Women See Men

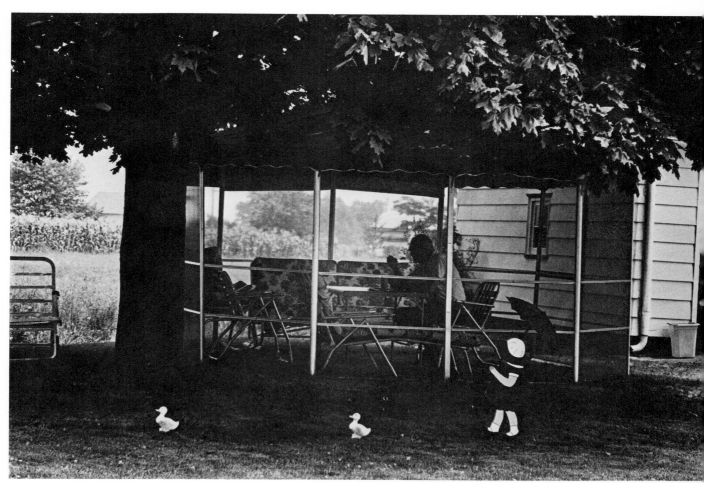

Mariette Pathy Allen

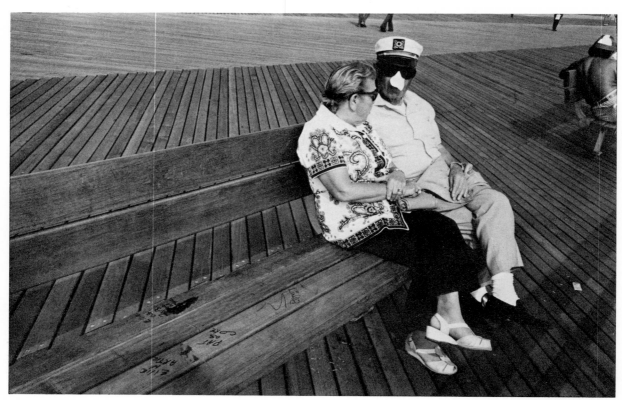

Linn Sage

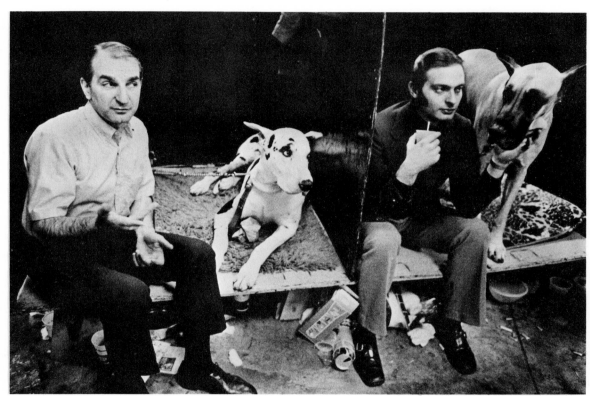

Suellen Snyder

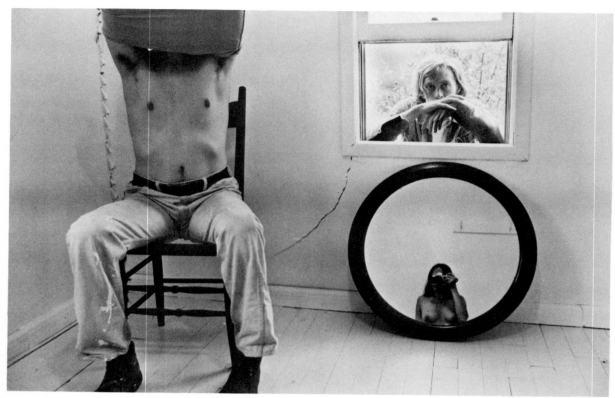

Naomi Bushman

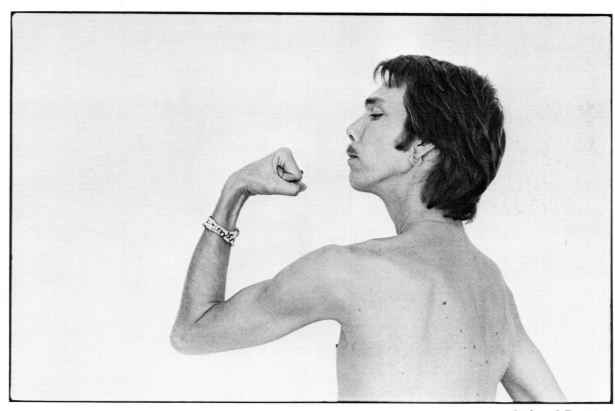

Andrea J. Bernstein

5

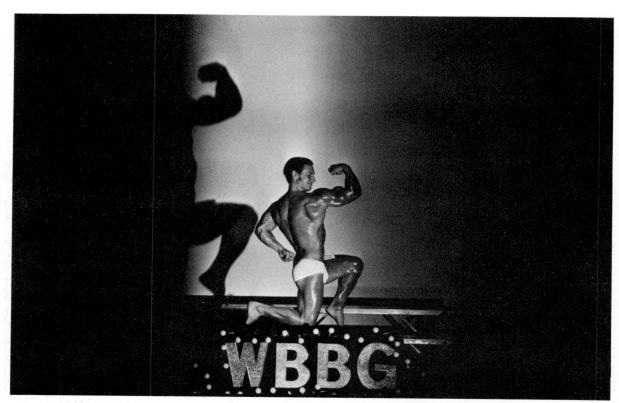

Linn Sage

6

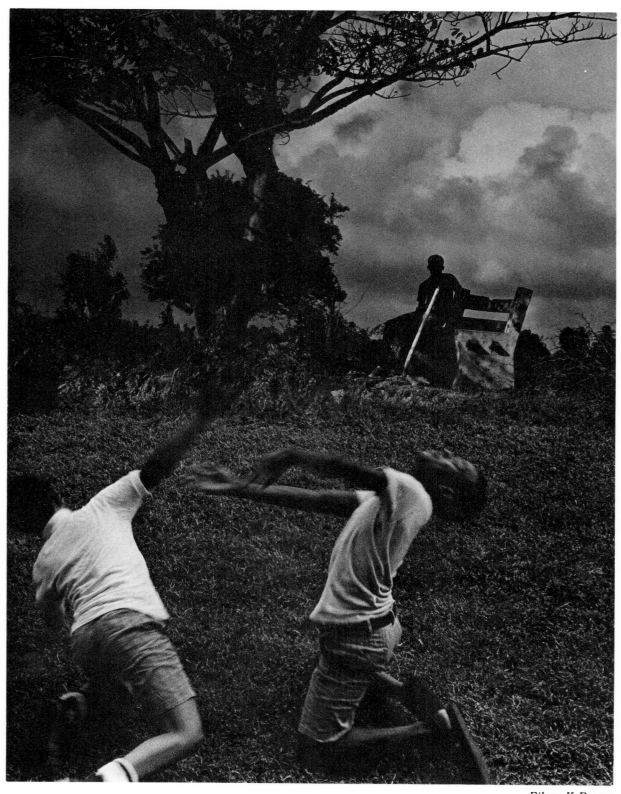

Eileen K. Berger

7

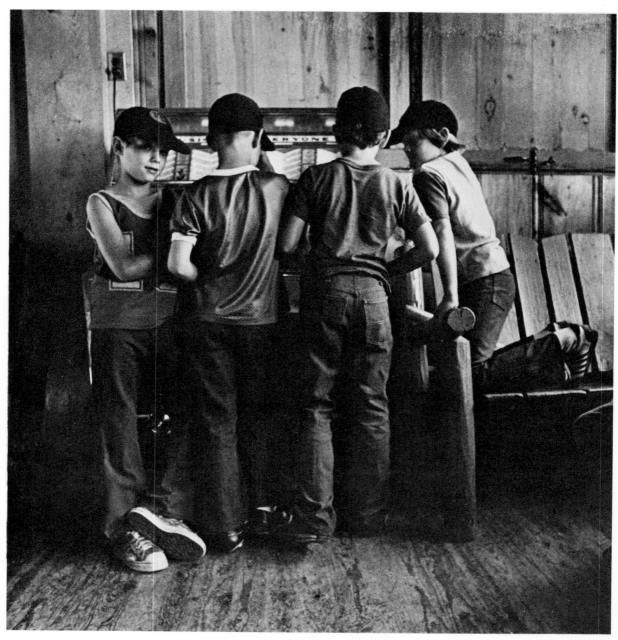

Rebecca Collette

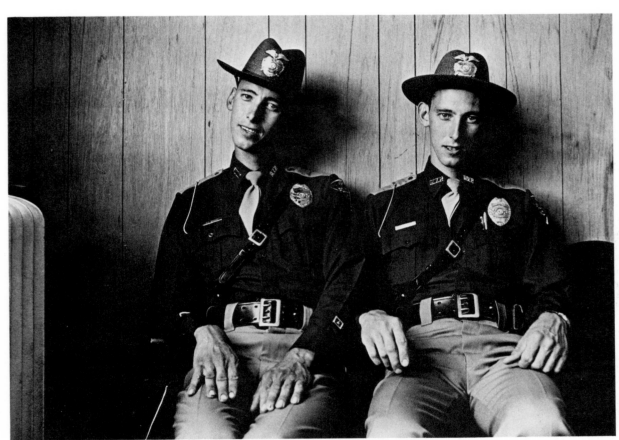

Rebecca Collette

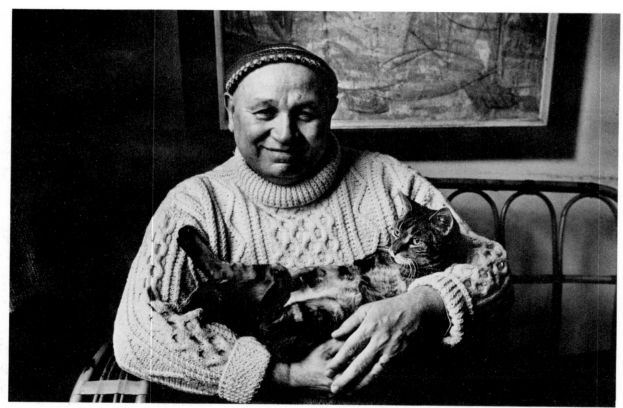

Nancy Crampton

Romare Bearden

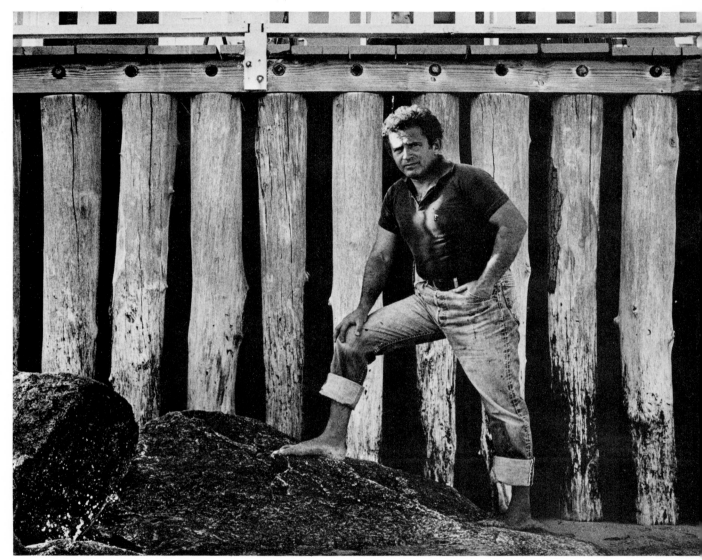

Dena

Norman Mailer

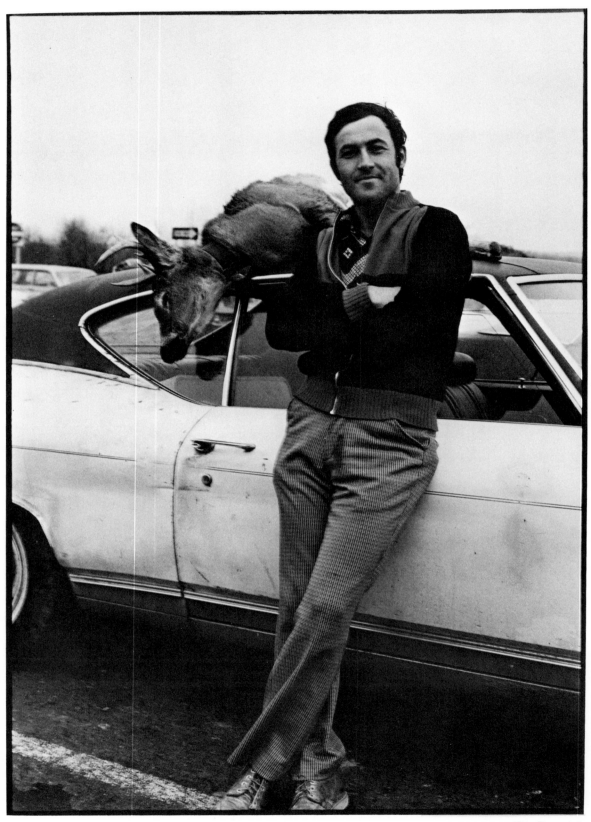

Nita Bernstein

That pride in the kill, that arrogance of conquest. Human beings eat and die; it is the same with animals. A fact of life, nothing more. And yet, there is something more powerful and persuasive here, as if the scent of blood itself was the original inspiration, tickling at the nostrils, causing the mouth to salivate and the heart to pound. Why the smirk? Why the profound pleasure in witnessing the ritual slaughter? It's an enigma, something impenetrable and atavistic.

Women have their blood roots: menstrual blood and birth. Is it possible that the opposite pole of this is men's obsession with

death, that somewhere along the line, blood must leave its mark: the philosophy of it, the fear of it, the quest for what might transcend it, the politics of it, the licensing of death, the act itself by war, murder, suicide, slaughter? From what bend in the heart does the urgency of the kill come? A gulf opens up between us, a gulf of incomprehension: no man can know labor pains; no woman can know the surge of pleasure as the animal falls to its knees. Something infinite and irreparable divides us at this point, a precipice at the limits of understanding.

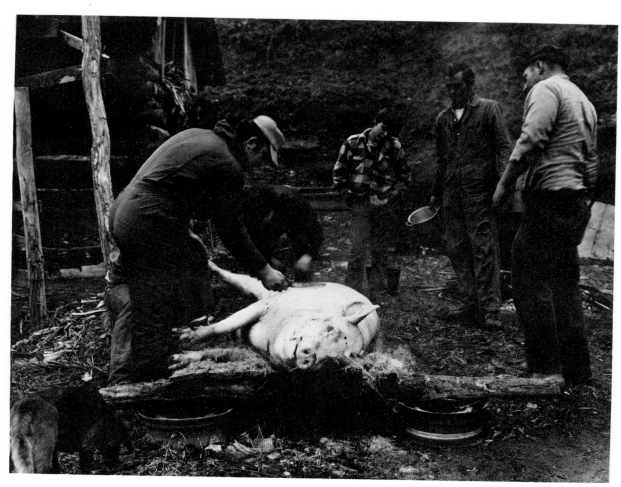

Wendy Ewald

15

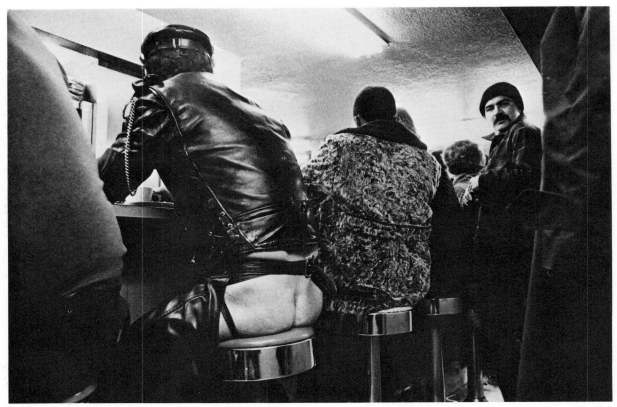

Flo Fox

16

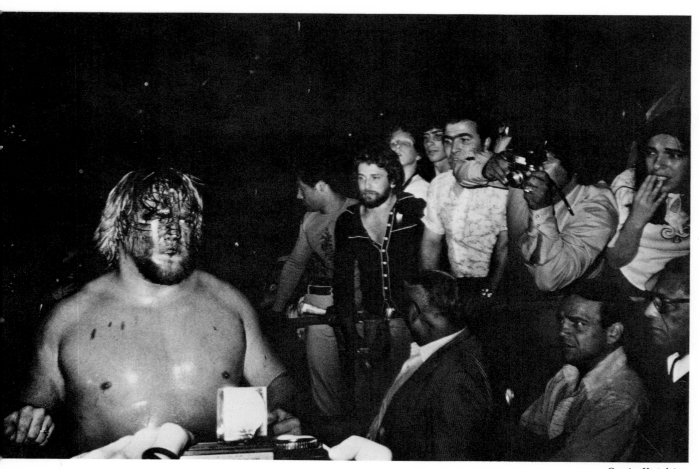

Sonia Katchian

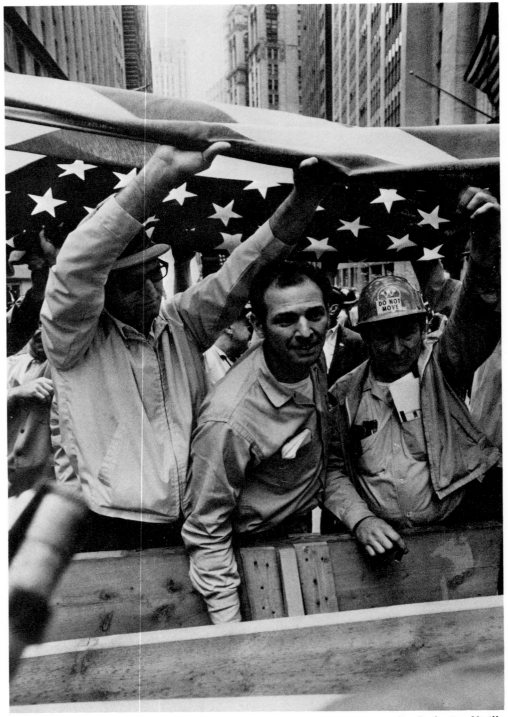

Catherine Ursillo

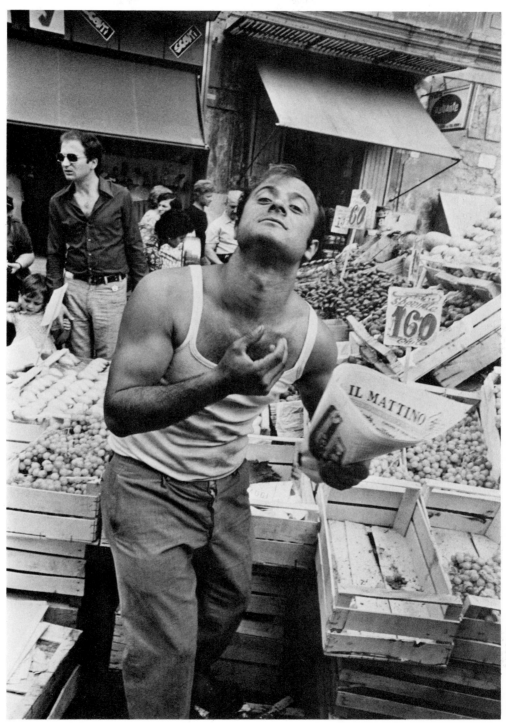

Catherine Ursillo

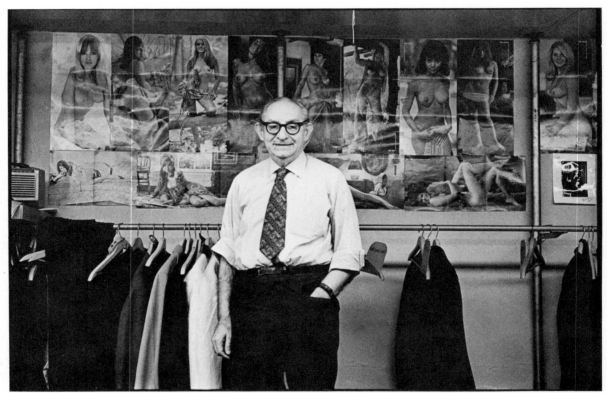

Sardi Klein

20

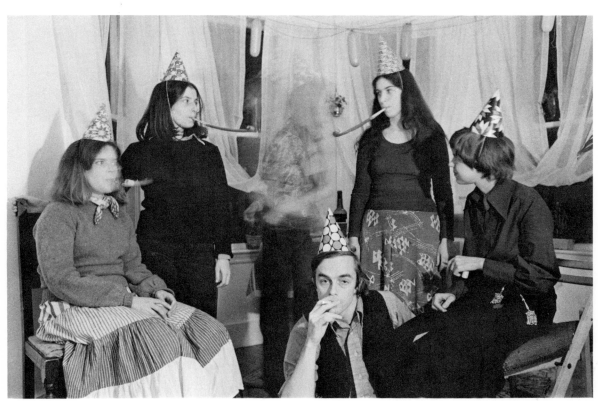

Eileen Friedenreich

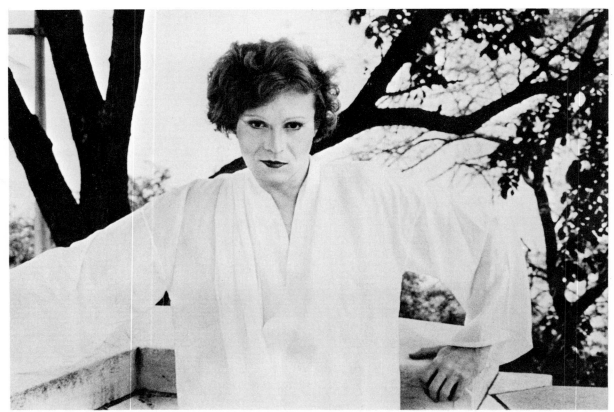

Marjorie Foy

22

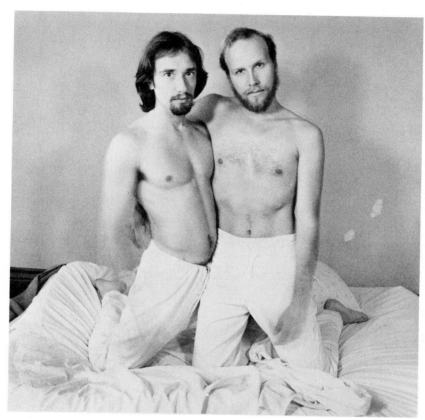

Phyllis Galembo

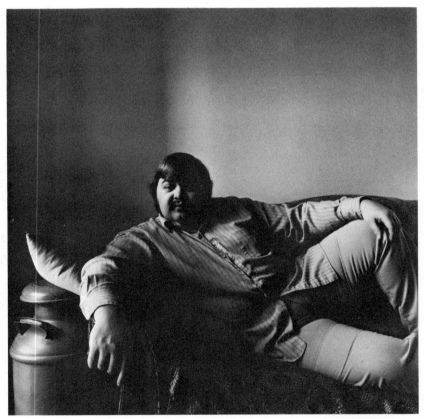

Phyllis Galembo

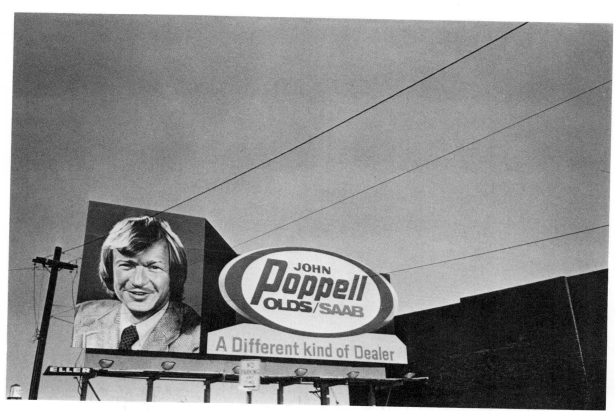

Roz Gerstein

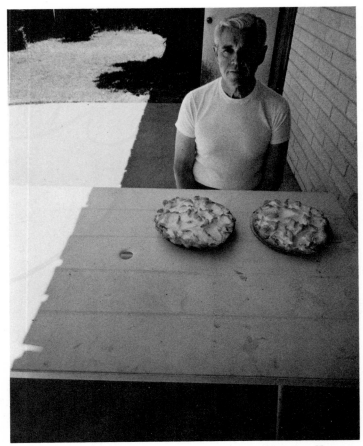

Christine Hornung

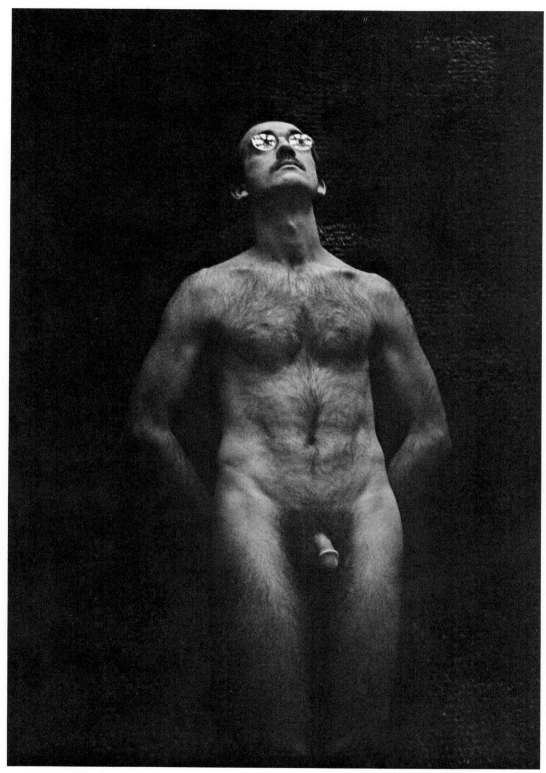

Karen Tweedy-Holmes

27

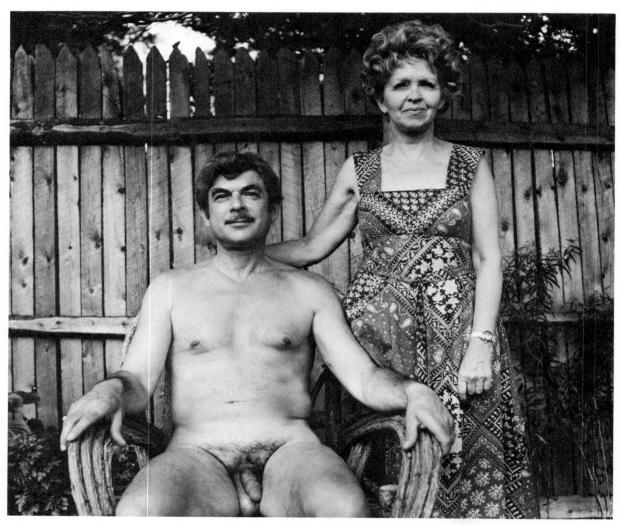

Penny Rakoff

28

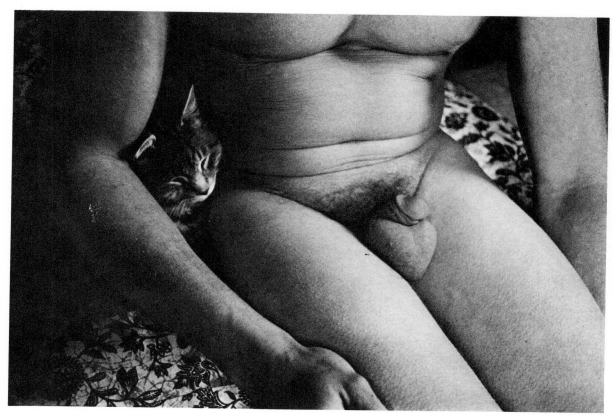

Penny Rakoff

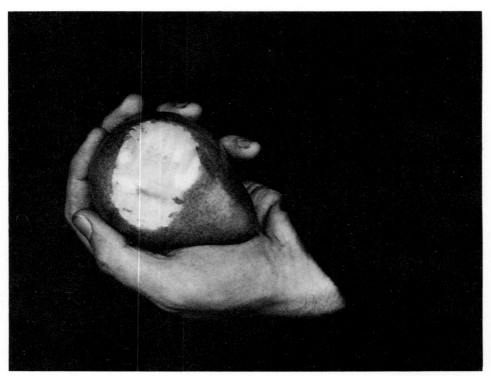

Susan Tinkelman

30

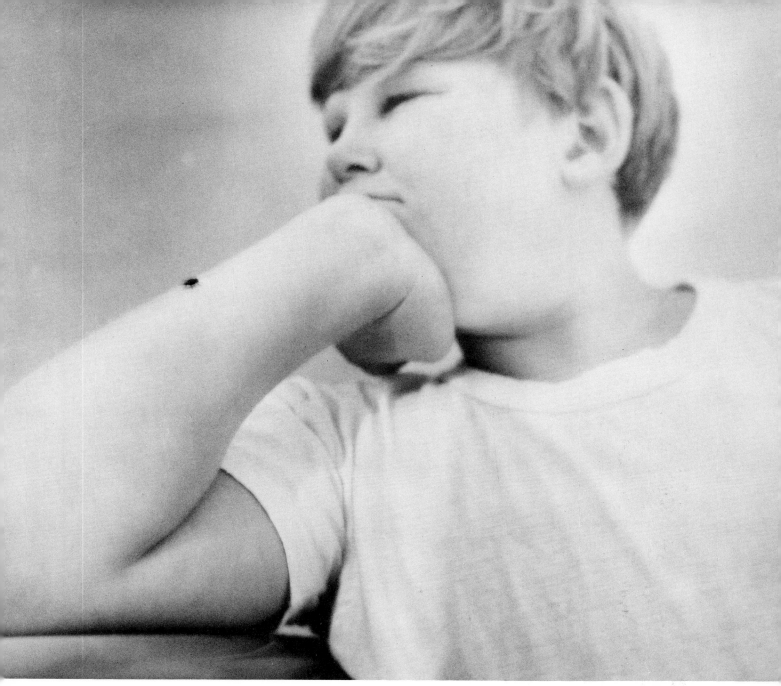

Kathy Tuite

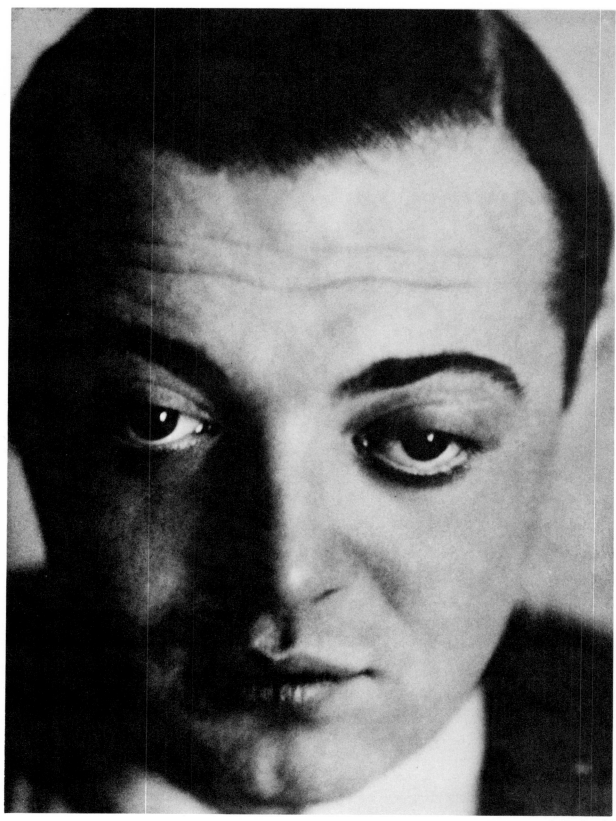

Lotte Jacobi

Peter Lorre

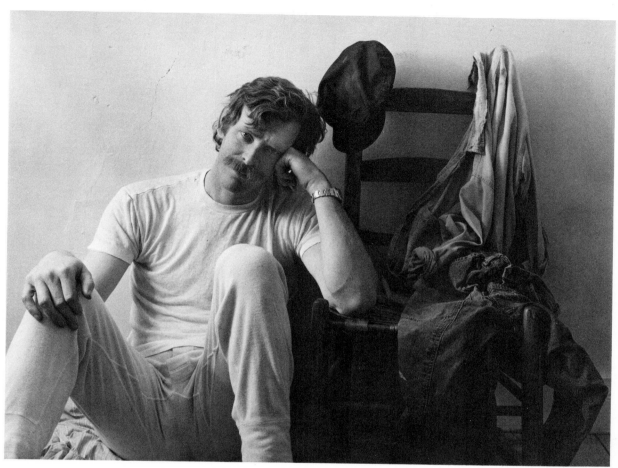

Ellen Foscue Johnson

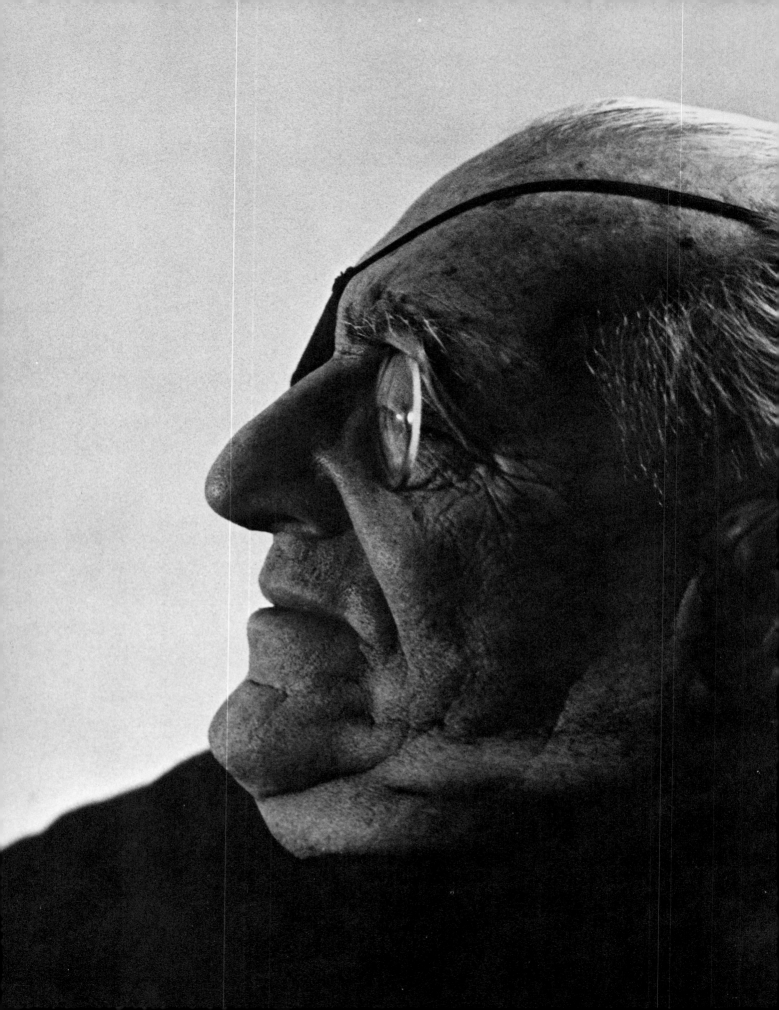

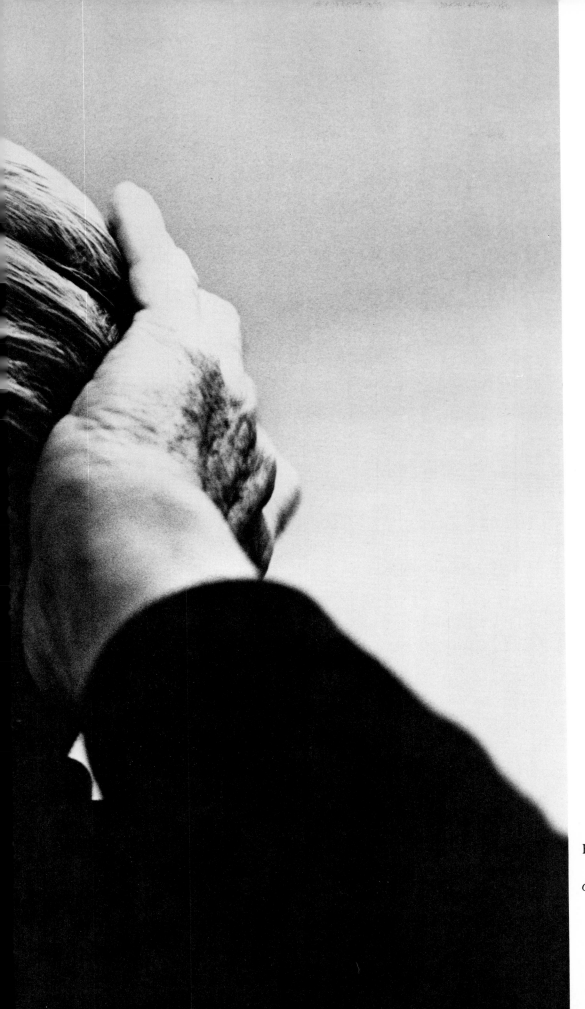

Fritz Lang

Gretchen Berg

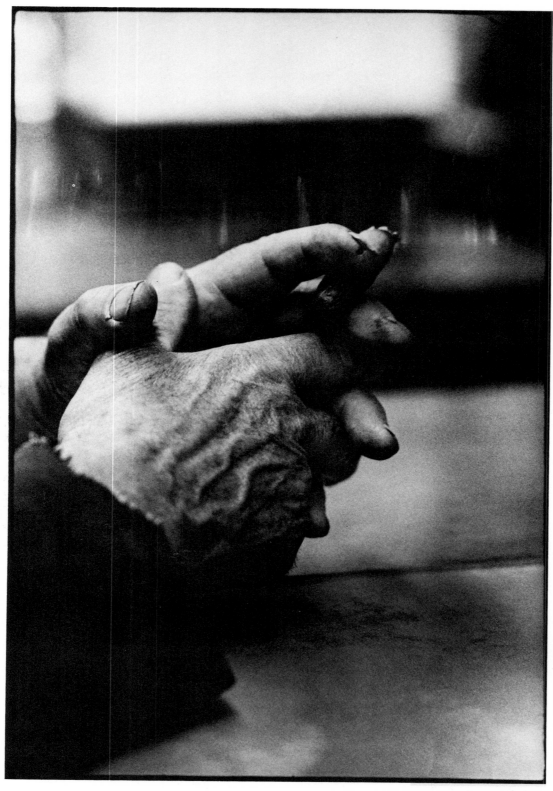

Sonia Katchian

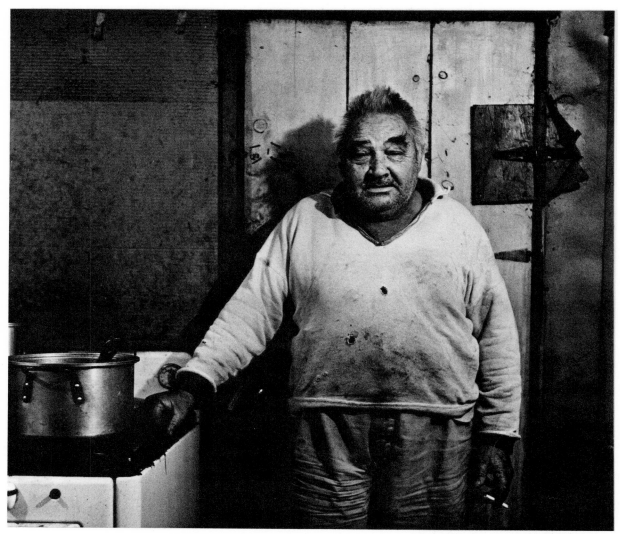

Selina M. Roberts

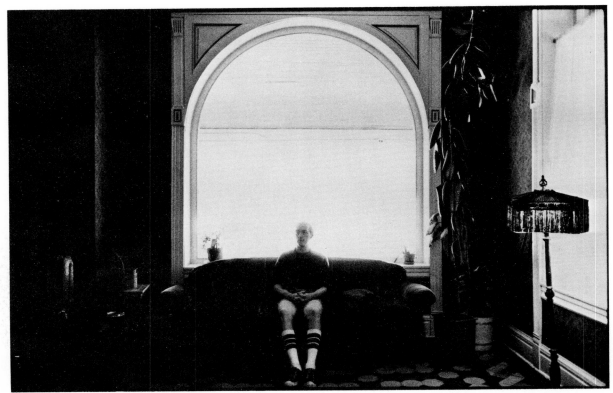

Caroline Reeves

Space is either everything or nothing. A man is either oblivious or overcome. The sport, hard-played, is over. The sweat and camaraderie and slight grubbiness, all gone. He rests in his solitude, fatigue so large that it outstrips even loneliness. To whom does this room belong? Is it home, the Club? Who could ever take possession of it? Coolness, spaciousness, elegance are treacherous traits: they convert too quickly into a violence of intangibility which retreats, refuses the confrontation, backs off into corners. He folds his hands and waits.

To move is to take possession of life. To move together is

to create a universe. In the pair's unobstructed glide across the room, the press of his palm against the small of her back, the sound of her high heels and the lean of her body are encapsulated in their feeling for perfection. Intimacy can dwarf almost everything: the room stretches infinite and unnoticed beyond them. There is a perfect stillness to which the accordion is merely an accompaniment. The accordionist agrees that they could go on forever without him. Though of course, they wouldn't. Bridging the gap in that illusion, he makes himself indispensable.

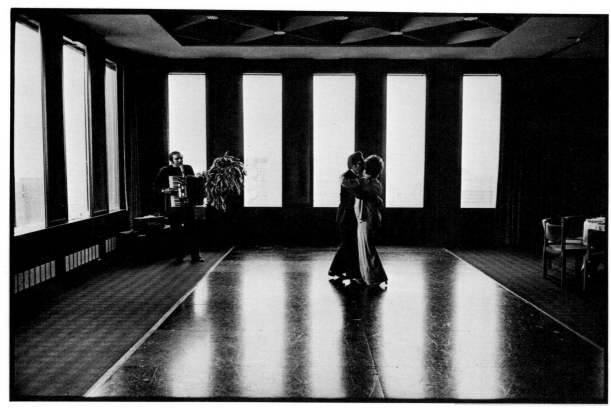

Sardi Klein

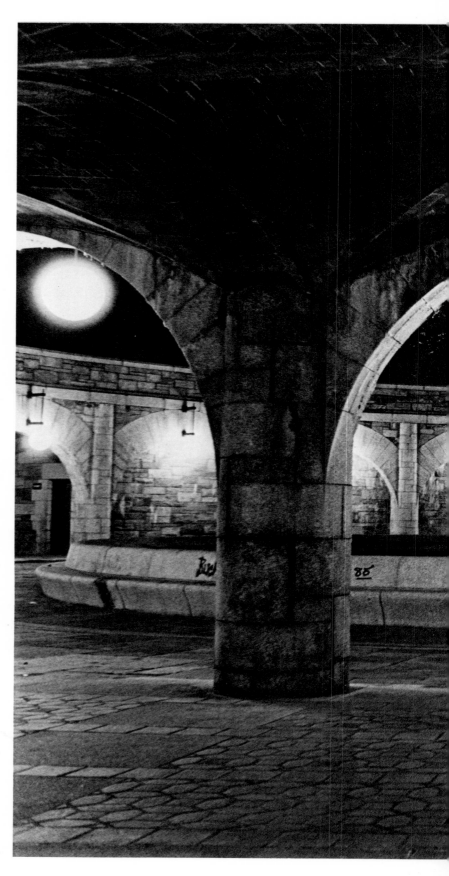

Ethel Virga

42

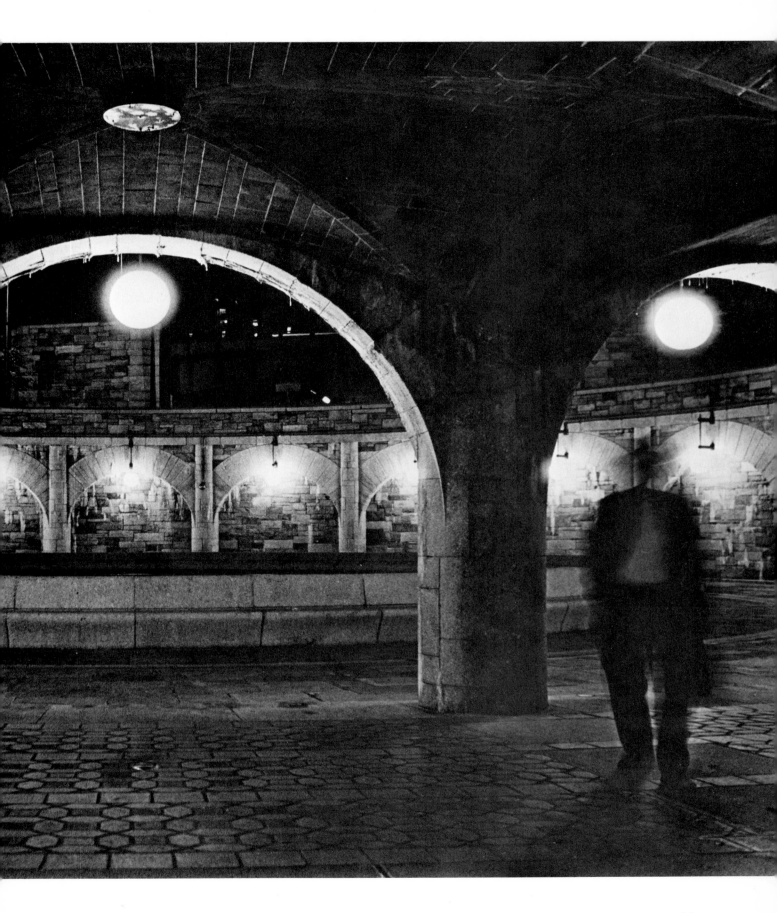

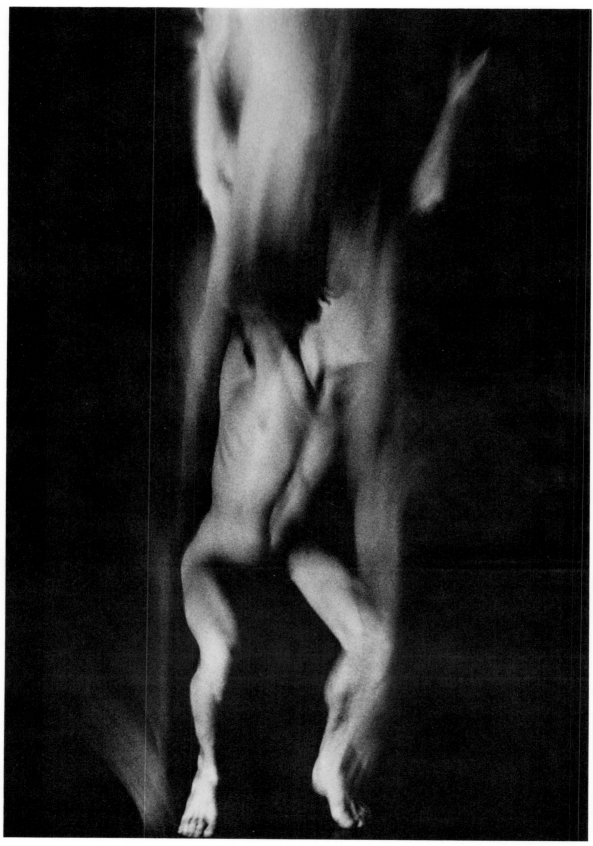

Sarah E. Leen

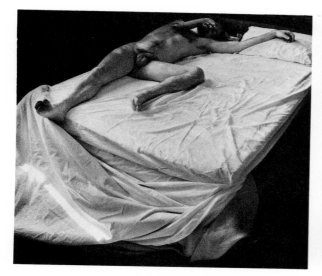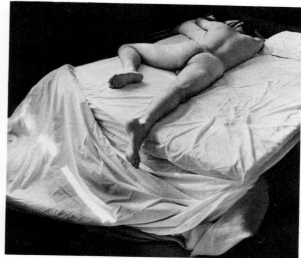

Joanne Leonard

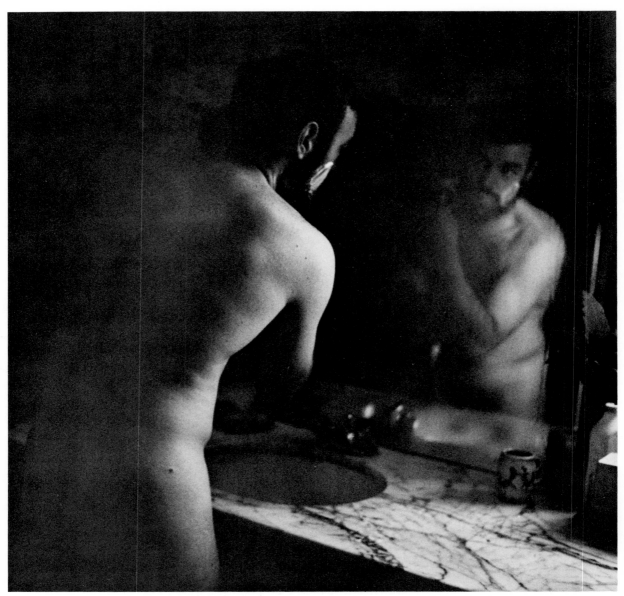

Joanne Leonard

46

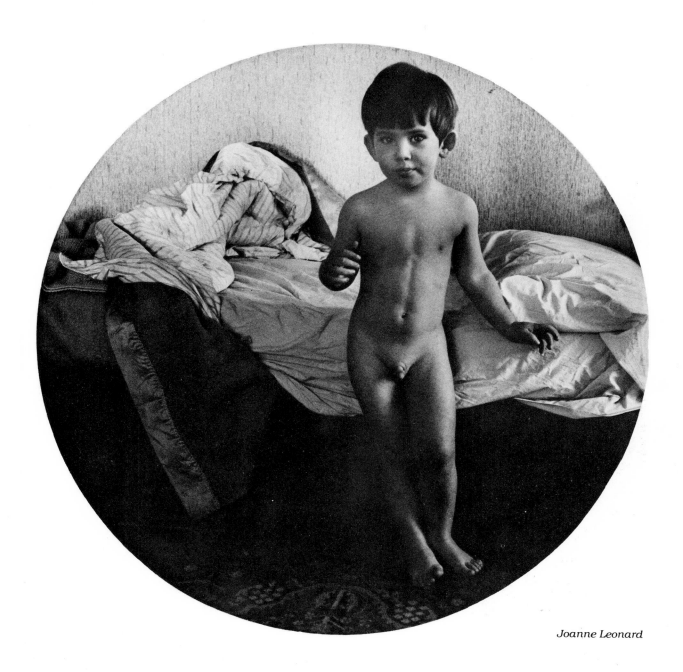

Joanne Leonard

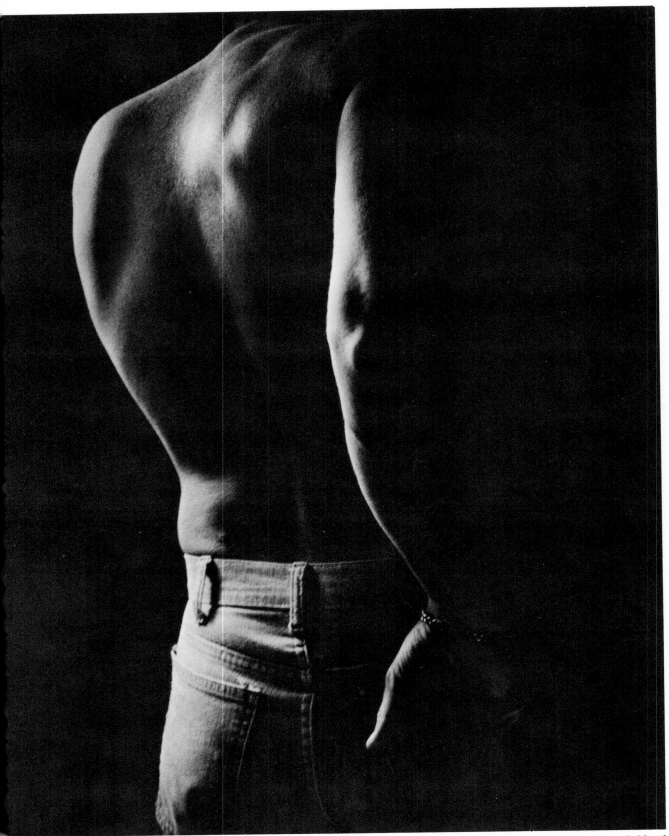

It is the most persuasive line of a man's body:
the back, from the base of the neck down to
just below the waist. He knows it, knows
from the softened eyes of women, though he
himself can see it only in a double mirror.
He considers it his possession, his territory,
his turf, a patrimony which need never be
earned. He has not thought about

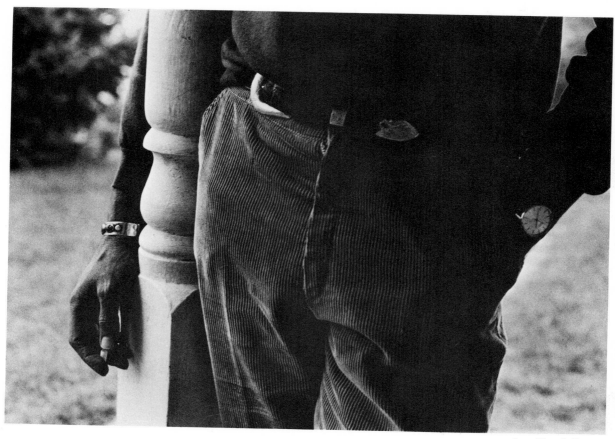

Ann Mandelbaum

Michelangelo or Donatello, not thought that there is an aesthetic cradled at the heart of women's desire. His language is blunter: he keeps his jeans low on the hips, walks bare-chested in spring, believing that it will all last forever.

Age brings a different grace, another eloquence, the look tempered by reflection and intelligence. Funny how he never cultivated his body. Just thought and walked and worked and wondered. His hands learned that repose is an act of labor. The length of his fingers, shape of his nails, angle of his hipbone: these could be earned only in the genes. No regimen of body building could give him the look of a life seriously lived, of character. He didn't plan to be either aesthetic or profligate. Corduroy and cotton and wool: they just felt right. Sometimes his cigarette burns all the way down without his taking more than two puffs. His shoes have crepe soles. On long nights, he thinks of all the things he's never done.

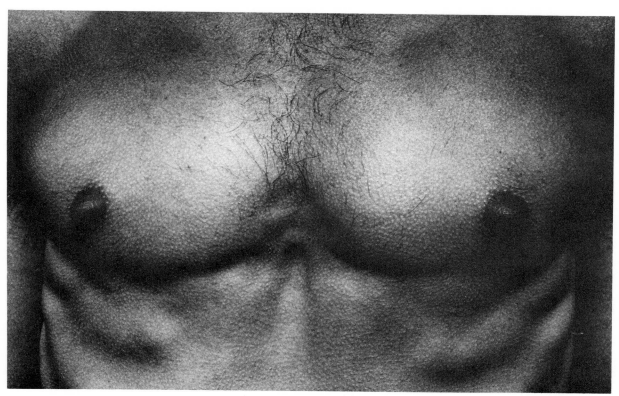

Dianora Niccolini

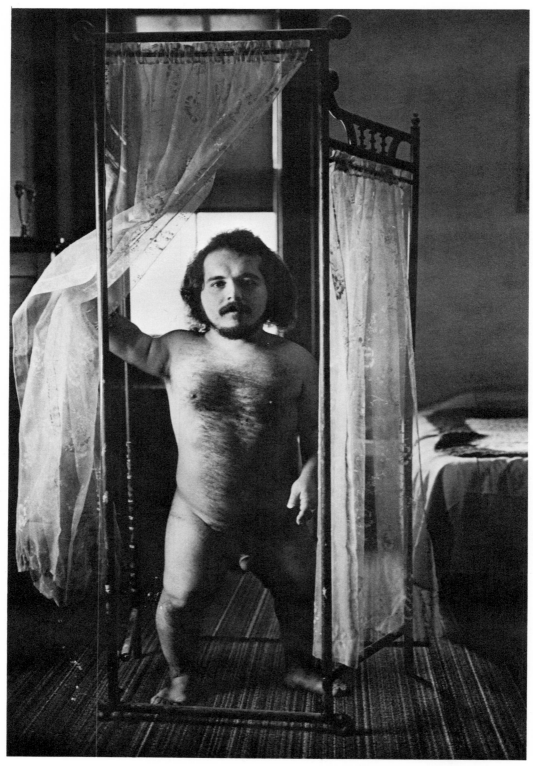

Vivienne Maricevic

52

Once in my favorite cafe, there was a handsome black man sitting at the table next to me. He was having an animated conversation with his friends about life in Barbados and jazz. When he stood up from the table, he was over seven feet tall. The cafe was filled with Italian women, mothers and grandmothers who came in every day for espresso and gossip. They talked about him, mocking and exalting him at the same time. They didn't realize that he understood Italian. He pretended to be unaffected. One old woman came over and tapped at his waist. She was probably five feet tall. She stood next to him, measuring herself against him. It was as if he were a big, well-proportioned tree, something to lean against, impervious to opinions. He was carrying a large artist's portfolio. The woman looked like a dwarf next to him. Every eye was on him. I wondered whether, over the years, he had become immune to people's stares. I couldn't help it. I stood up too. I had the sudden feeling that the presence of a tall woman in the room would be a kind of reassurance, a way of saying 'hello.' He didn't notice. Anyway, he was Gulliver among the Lilliputians. But a dwarf alone in a hotel room. He comes naked from behind the curtain, enveloped in a loneliness which is final.

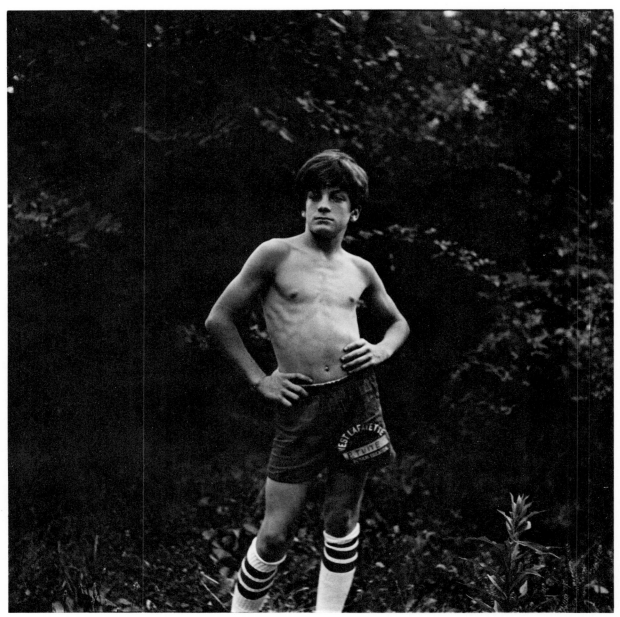

Kathy Tuite

54

The maternal eye always seizes something of the future, wondering whether that leg, cramped too long by cast and crutches, will end up half an inch shorter than the other. He's growing so fast now: his bones are growing. He's been patient through it all, but his face has deepened. He's learned something about resignation. She loves him with an ache, this boy, the perfect reflection of her

desires. Will he ever again be so vulnerable?

And what of the other's growth, inner, less visible, his soft
love of all that is spread out before him, these woman's things.
On the vast domain of his bed, everything assumes its proper
shape. He recedes inward, dwarfed by the objects. Private. All
that they both become will be private. She can watch, fuss, worry.
By day, she lets them struggle alone with their crutches.

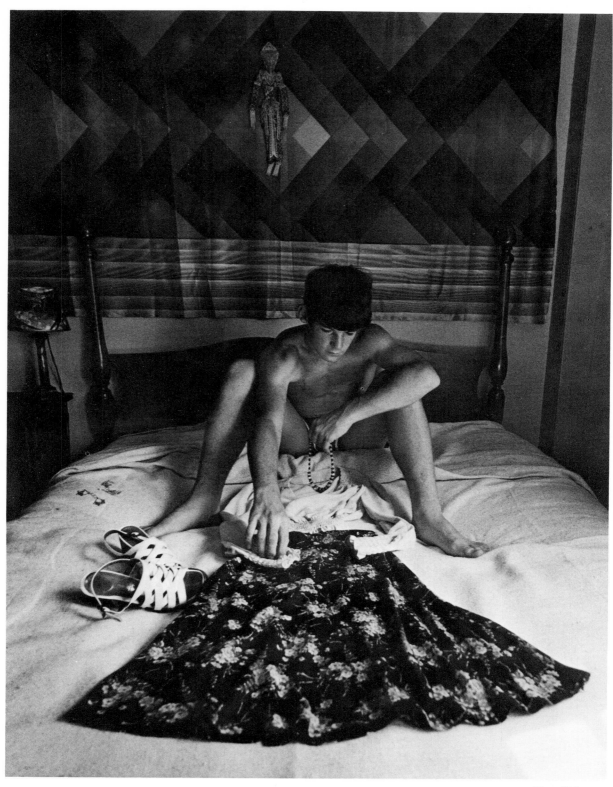

Starr Ockenga

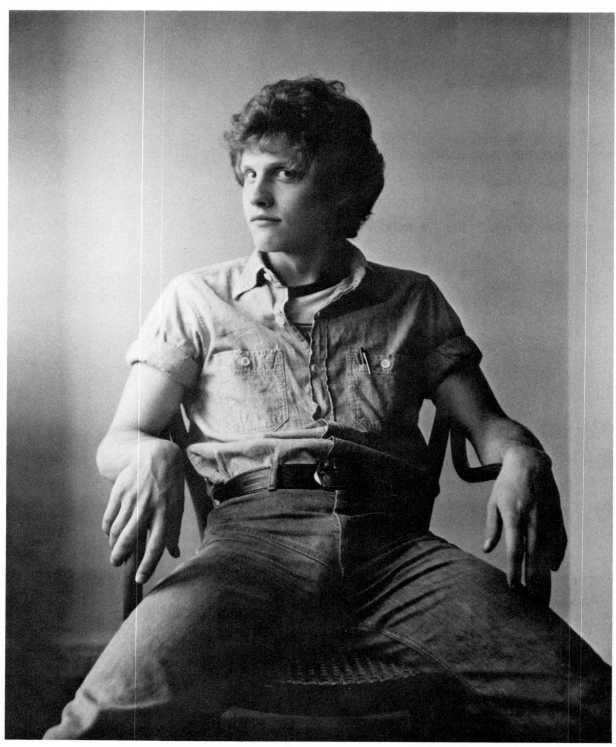

Lida Moser

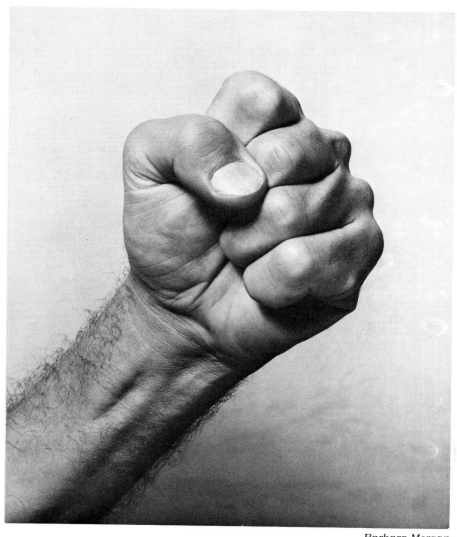

Barbara Morgan

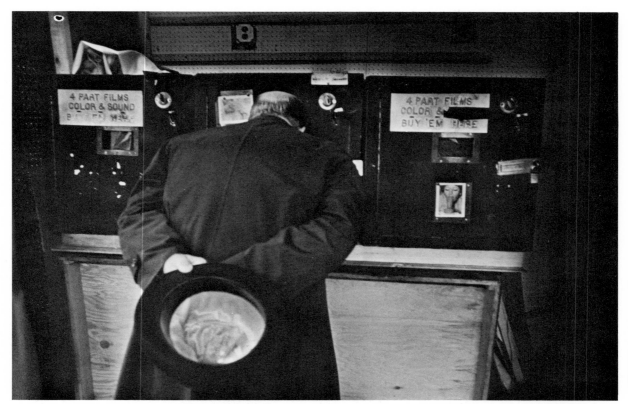

Sonia Katchian

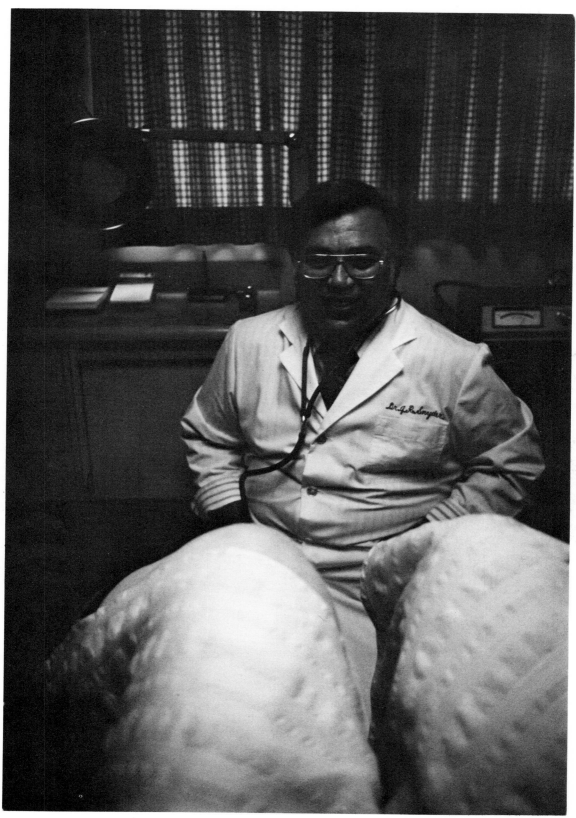

Elaine O'Neil

Abbey Robinson

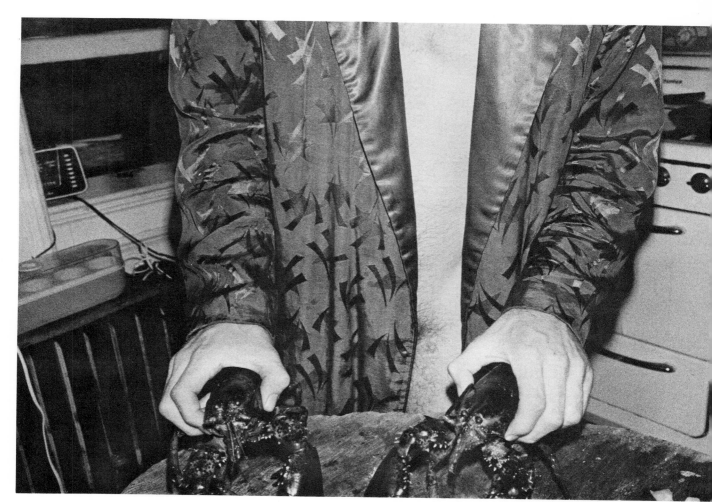

Abbey Robinson

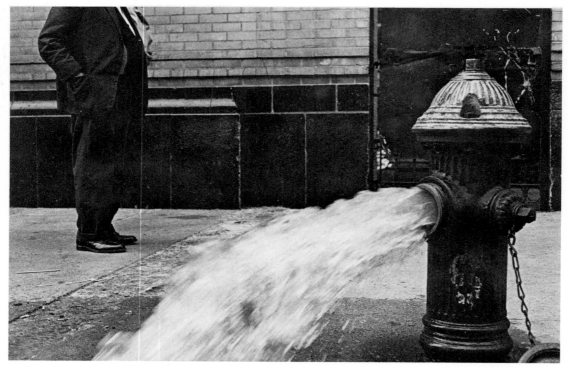

Abbey Robinson

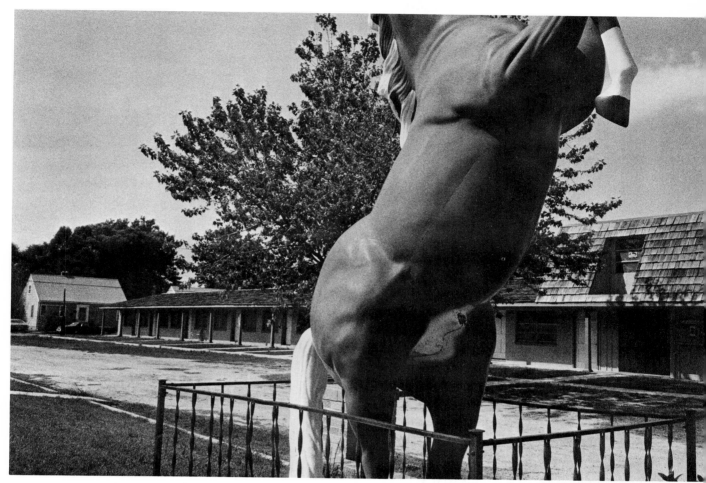

Abbey Robinson

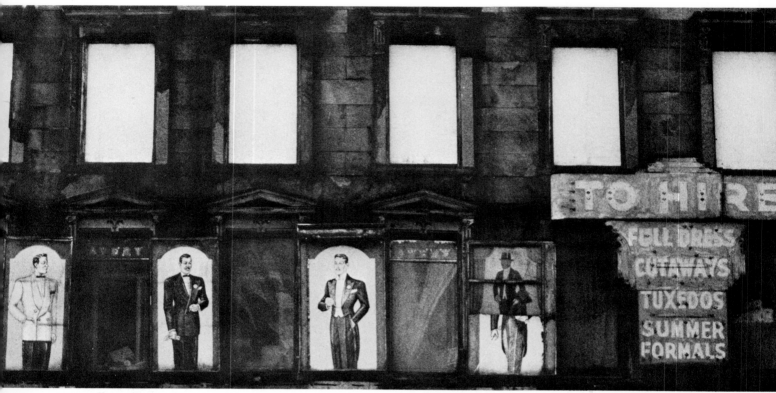

Nina Howell Starr

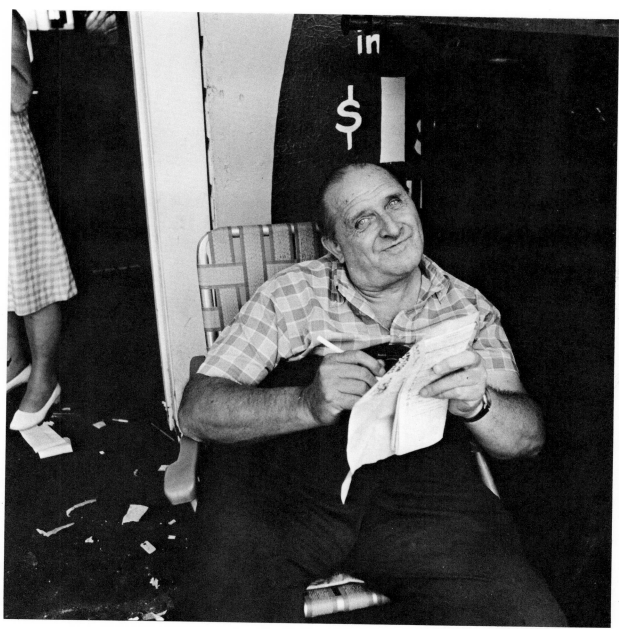

Lucia A. Spurgeon

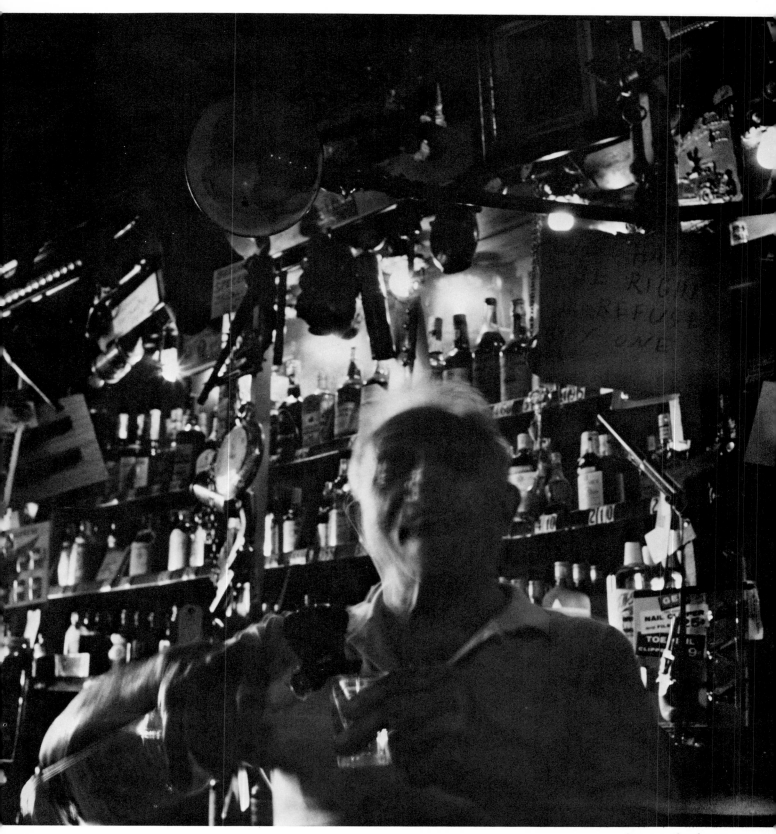

Suzanne Seed

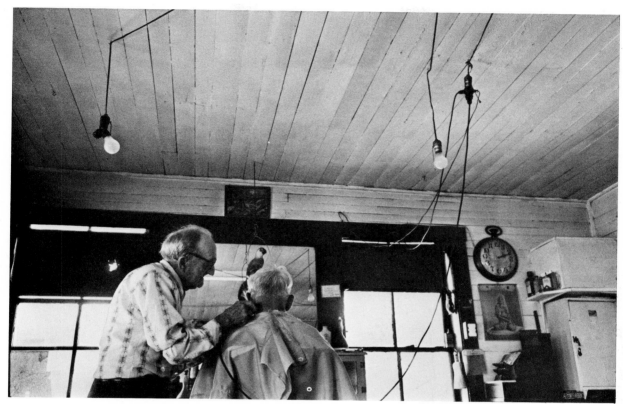

Linn Sage

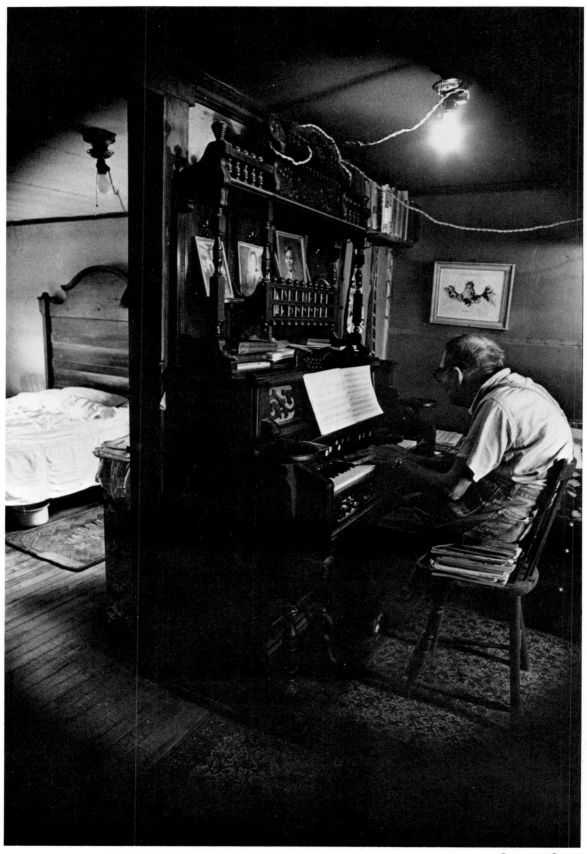

Suzanne Opton

It is in these intense acts of concentration, these moments when nothing is said, that men reveal themselves. Circuitous, self-conscious, indirect, their love of things is a private pact, a solitary act performed equally well among communicants of flesh and blood or wood and ivory. Solace is found in ritual repetitions, where talk can't find a wedge. Solitude is not loneliness when beyond the bed there is sheet music, a keyboard, familiar notes, photographs of grandchildren, newspapers which raise the chair to a comfortable height. The notes speak through him, out of himself.

in a language beyond the excess of words. Peace is the object and a filtered passion: no inner territory is conquered by speech.

The card players, meeting every day for years, still speak only of the weather, a hand played well or badly, what has happened to the Paris they used to know. This at least is intact, a domain maintained, impervious to change, as solid as the Eiffel Tower. The familiar place is everything, the fierce clinging to the habits of an invisible affection, life breathed into the cards themselves. To them, friendship is confirmed when it can be taken for granted. Old men have their rules: arrive each day for the game; play it quietly and well. Return. You are my friend because you are here and have been here each day for twenty years. What more is there to be said?

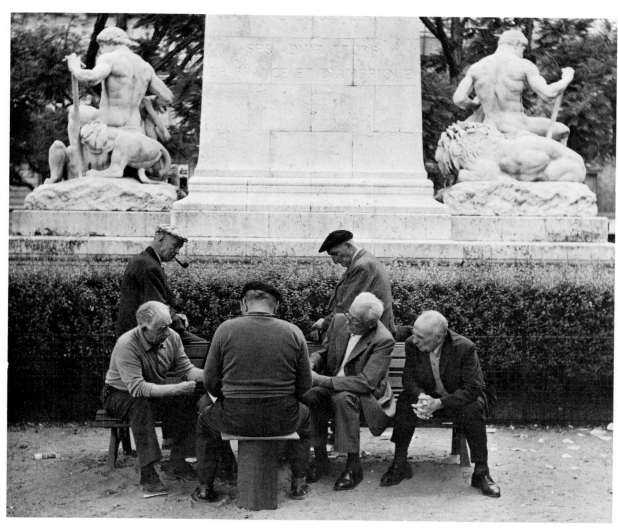

Sherry Solomon

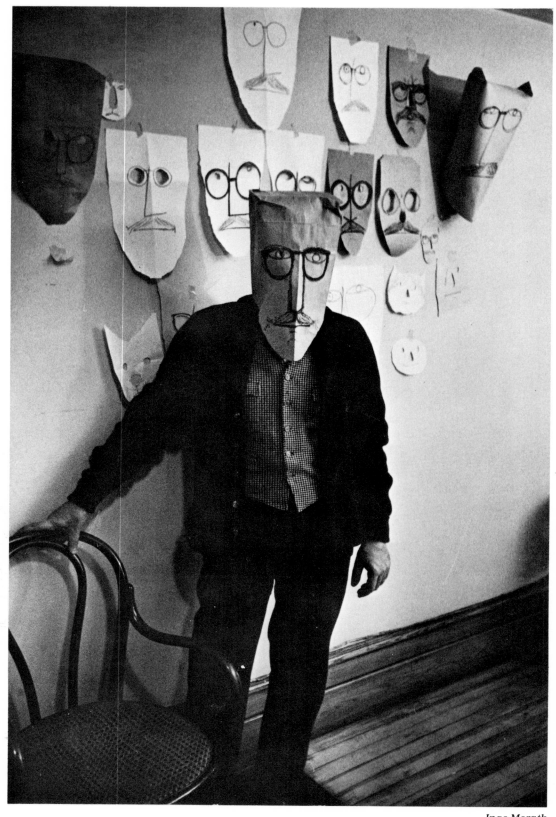

Inge Morath

Saul Steinberg

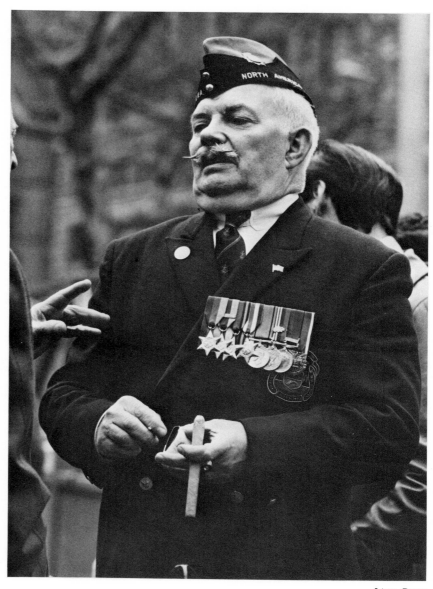

Linn Sage

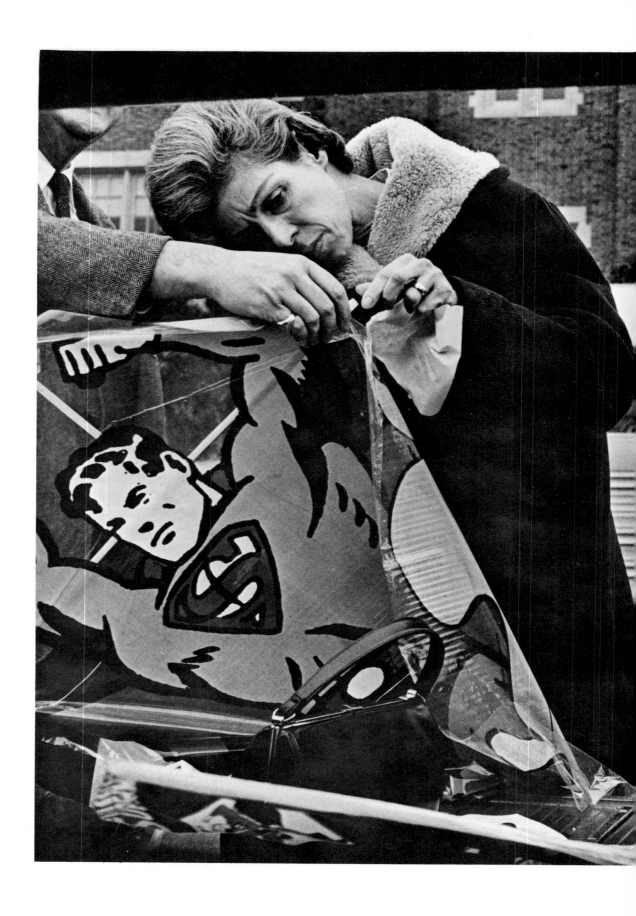

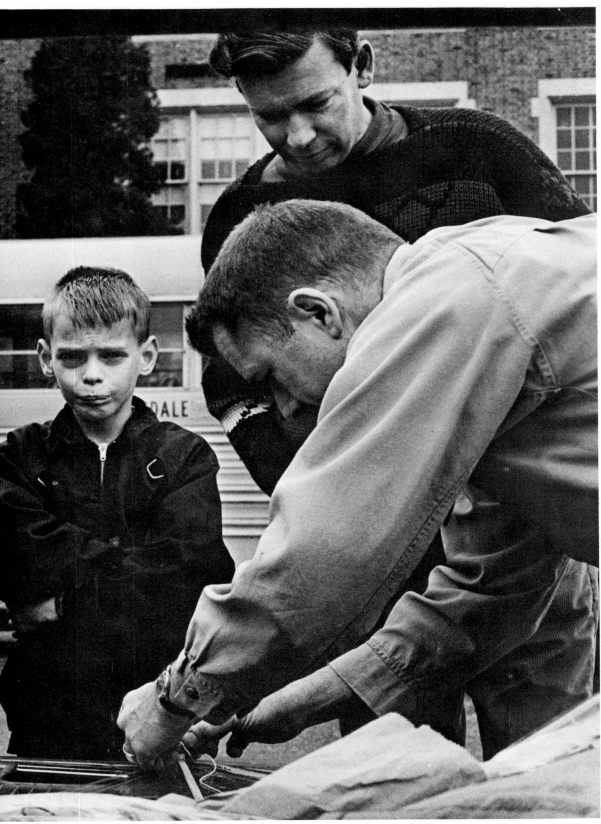

Sylvia Plachy

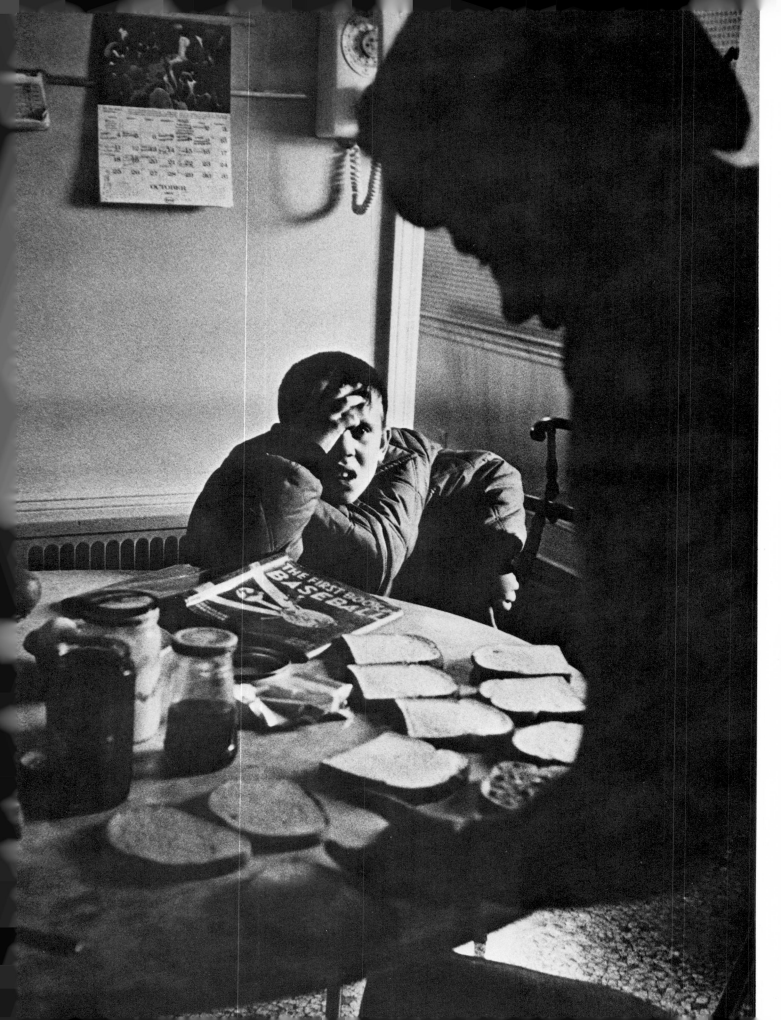

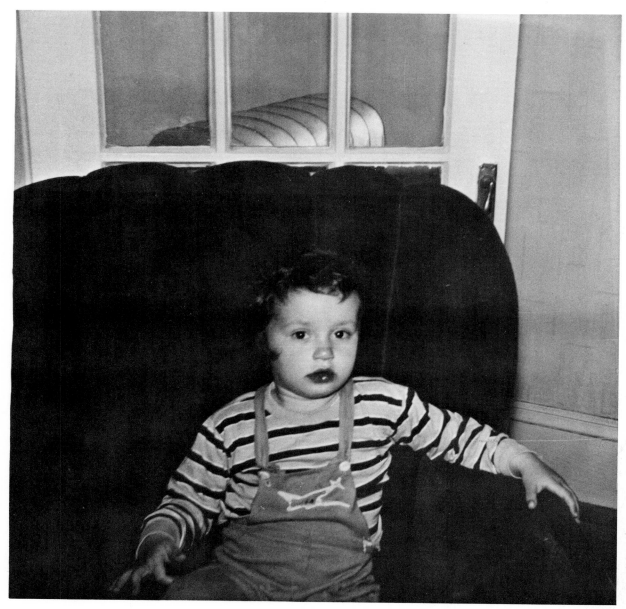

Gail Rubini

Sura Ruth

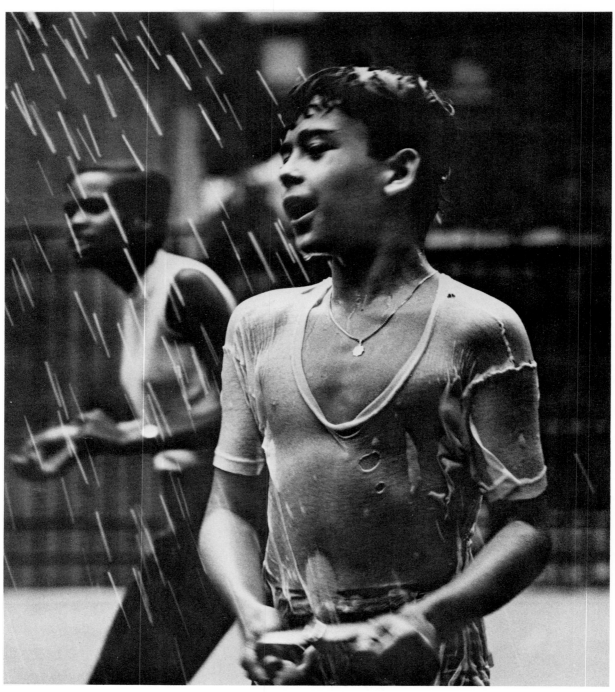

Marjorie Pickens

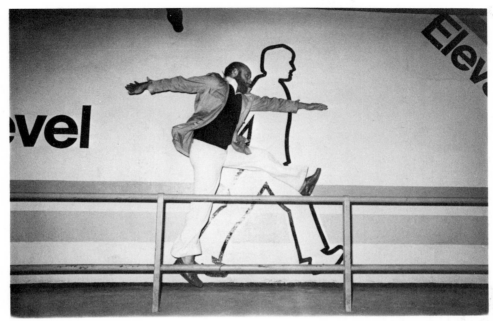

Joyce Ravid

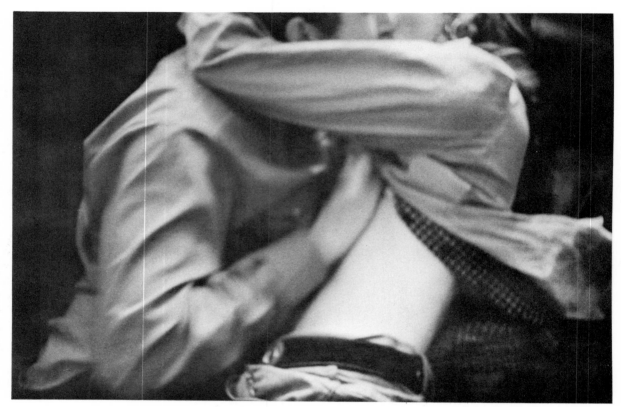

Nancy Polin

84

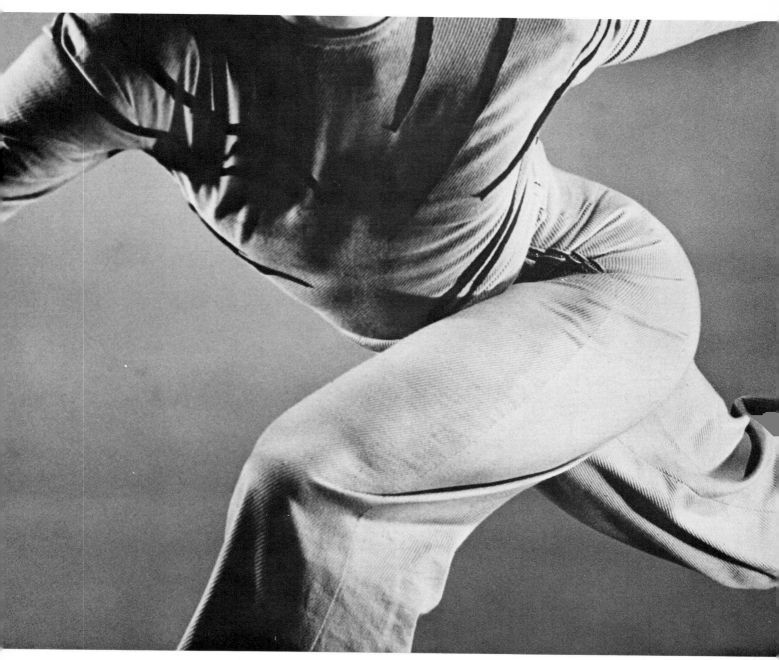

Barbara Morgan

Merce Cunningham

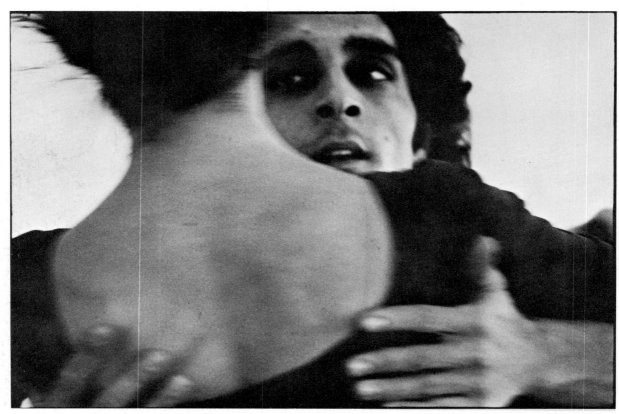

Marjorie Shostak

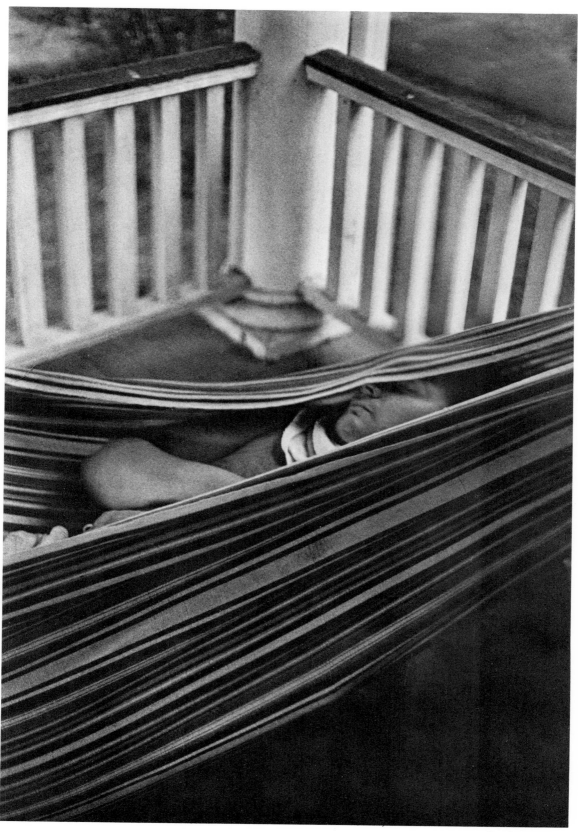

Suellen Snyder

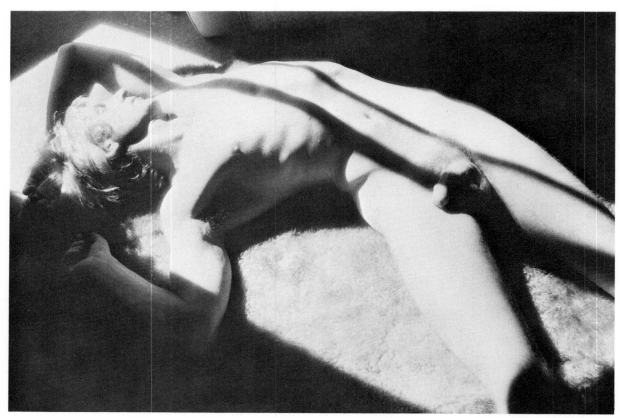

Bernis von zur Muehlen

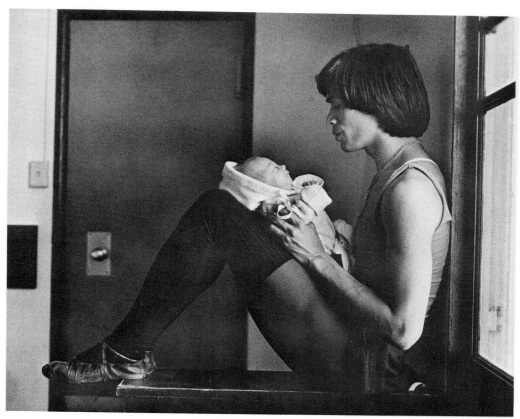

Jacqueline Poitier

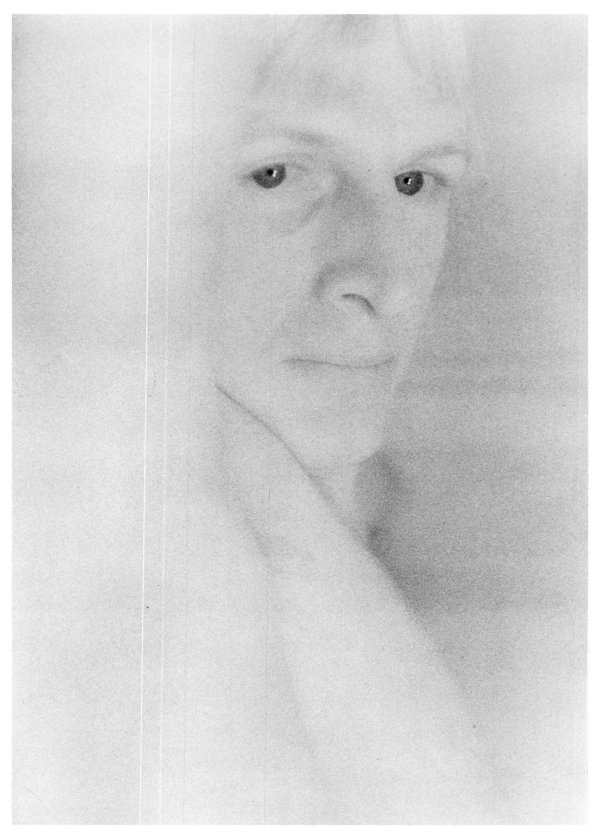

Bernis von zur Muehlen

90

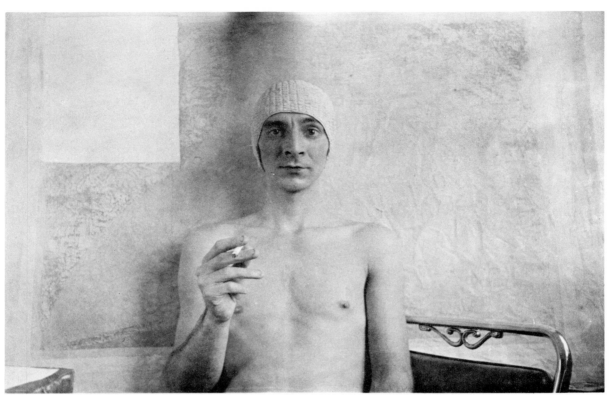

Eva Weiss

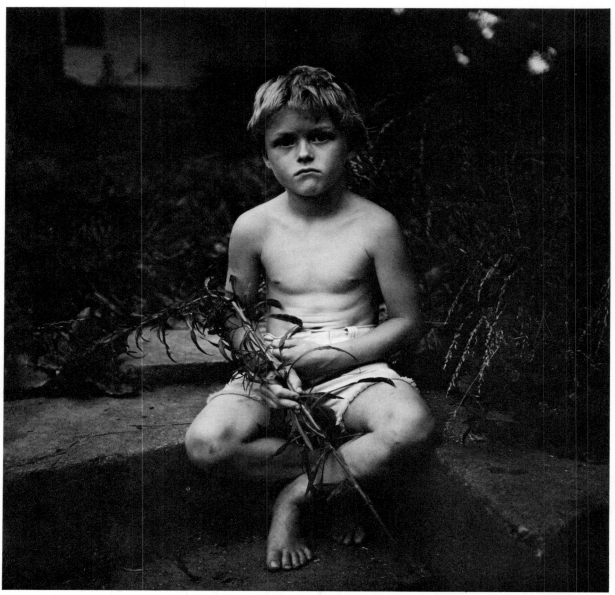

Elizabeth Turk

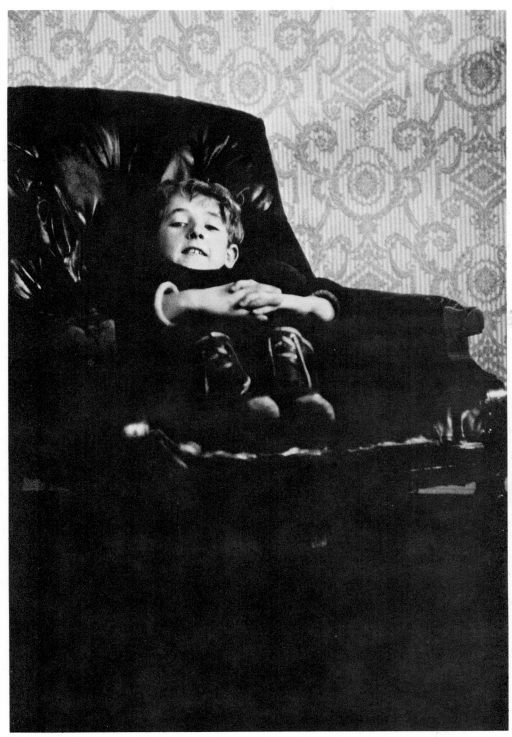

Susan Houghtaling

She once said that seeing a man play with his children always made her cry. Her husband had never done it with their children; her father had never done it with her. She found it remarkable that other fathers did that with their children and grandchildren. Sometimes she followed them, or stood, rooted to the spot, watching. That a man should be so engrossed…remarkable…remarkable. Her entire system yielded itself to them: she nursed the image at her breast. A magical kingdom of the commonplace. But then, how could love ever be commonplace?

The nape of a man's neck is the most intimate place on his body. Long hair has changed all this. Shoulder length locks may be "feminine," but how much more evocative of tenderness and warmth was that bare neck, with the straight cut hairline just above the nape, the twin hollows on either side of the center. There's a stubborn, sweet endurance in that head. Strong nerves. But what if the babies keep crying? How long will his patience endure? And then what? Can he hand the two shrieking shapes over to her? Or are they his, at his ears, at his shoulder, clinging, for better or for worse, in sickness and in health? The tender nape of the neck.

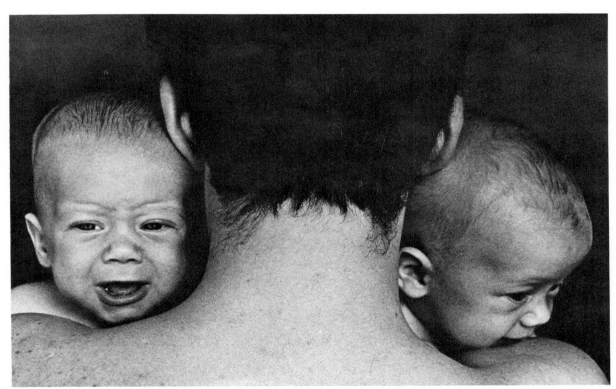

Dorien Grunbaum

And she, the black girl child, hanging on
Daddy's head. She is thirty years old,
and wise in the eyes. A woman, Delilah,
to whom Samson surrenders. Seduction
is stronger than screams. He will hold
her high above him for hours, if need
be. What a pride she is, my girl. Let
everyone see. My girl. My gorgeous girl.
She looks just like me.

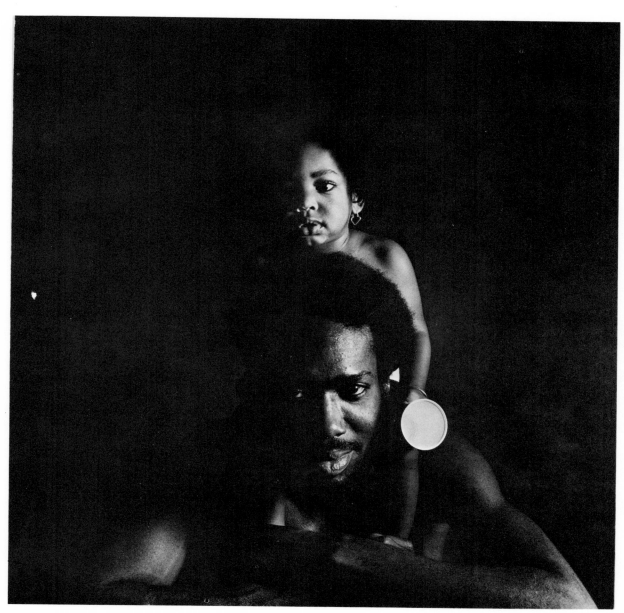

Leigh H. Mosley

97

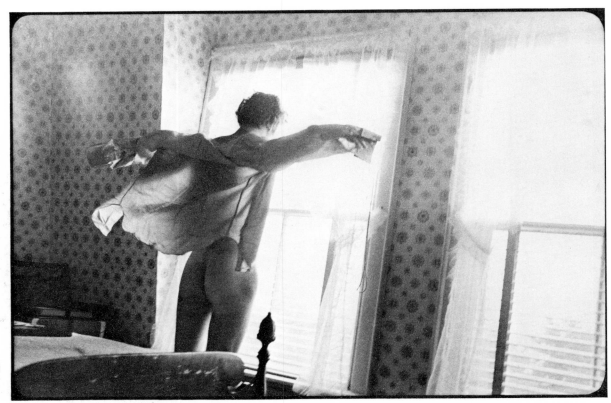

Gail Russell

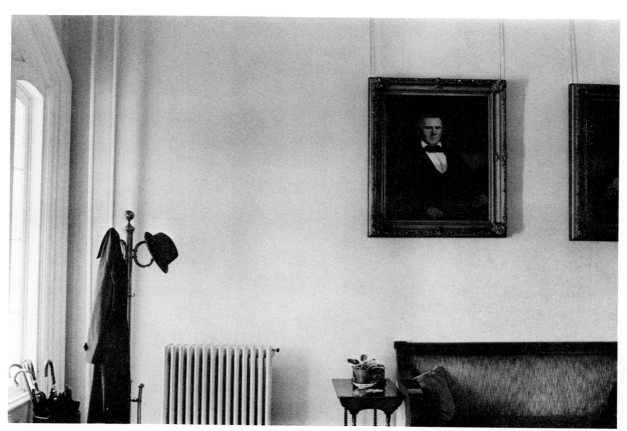

Elizabeth Matheson

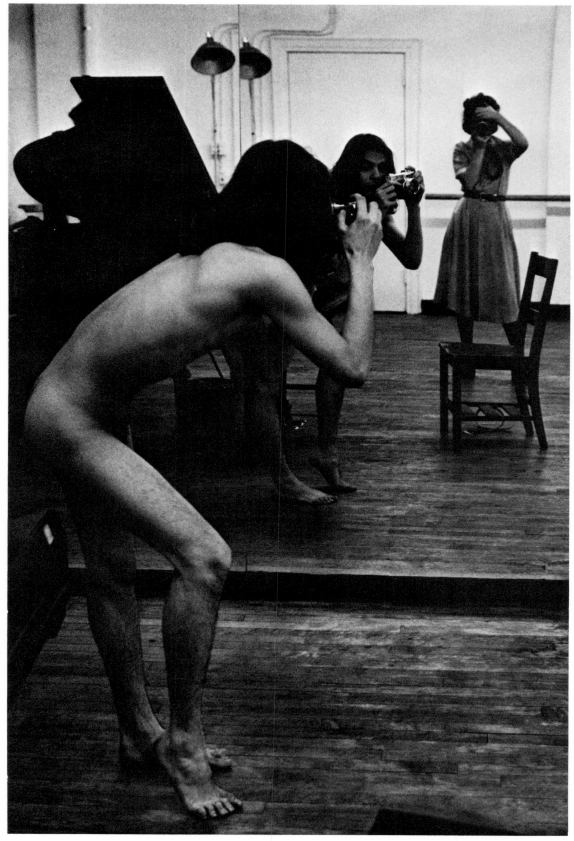

Carol Weinberg

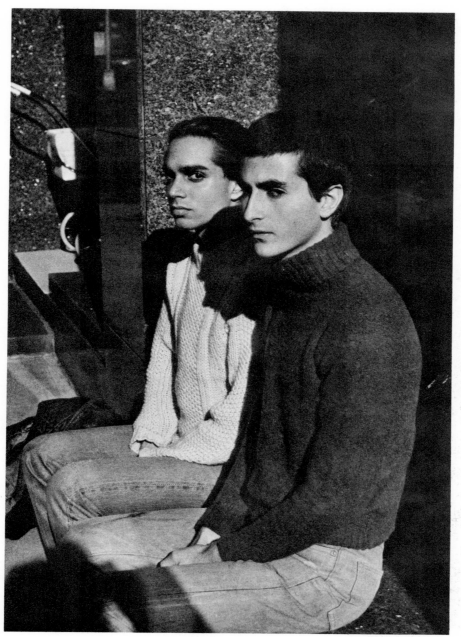

Carol Weinberg

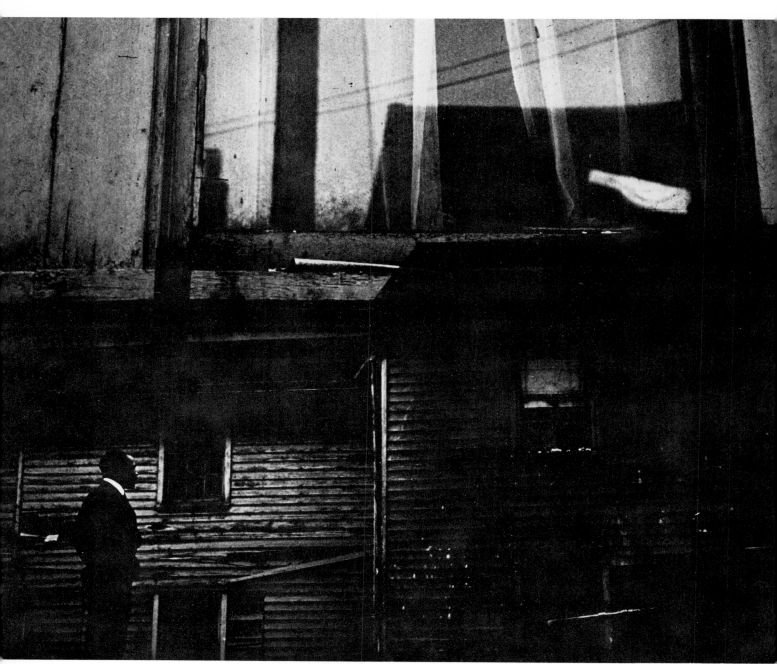

Carol Wald

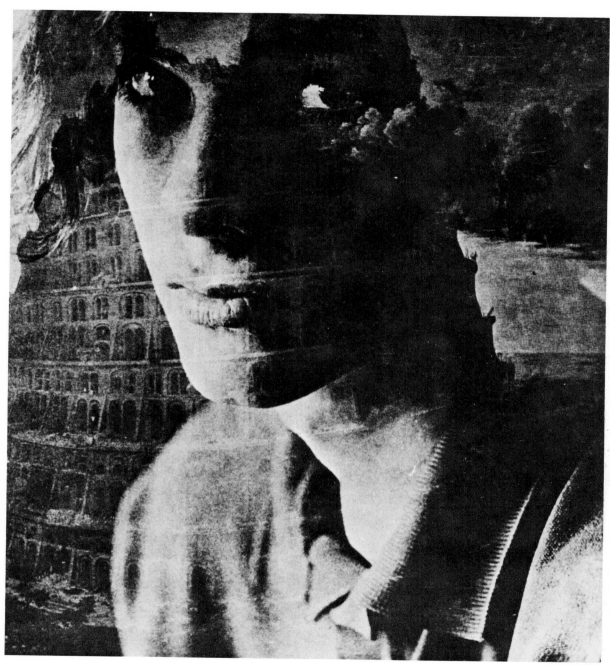

Carol Wald

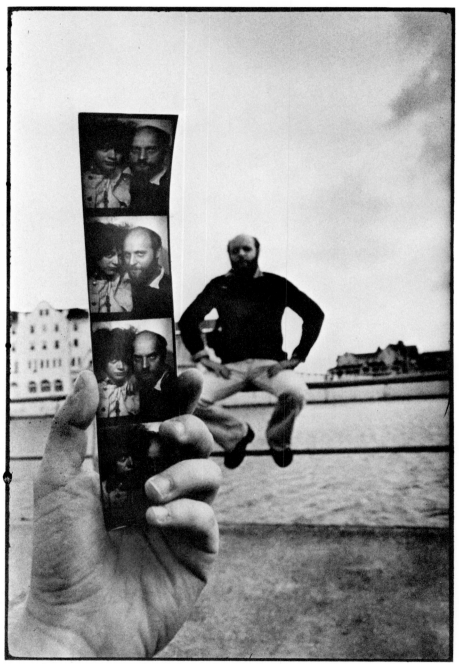

Joyce Ravid

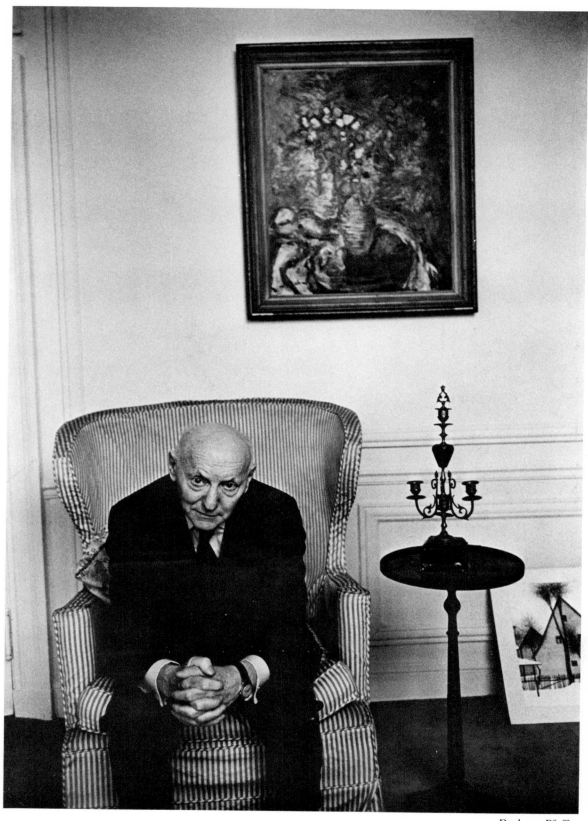

Barbara Pfeffer

Isaac Bashevis Singer

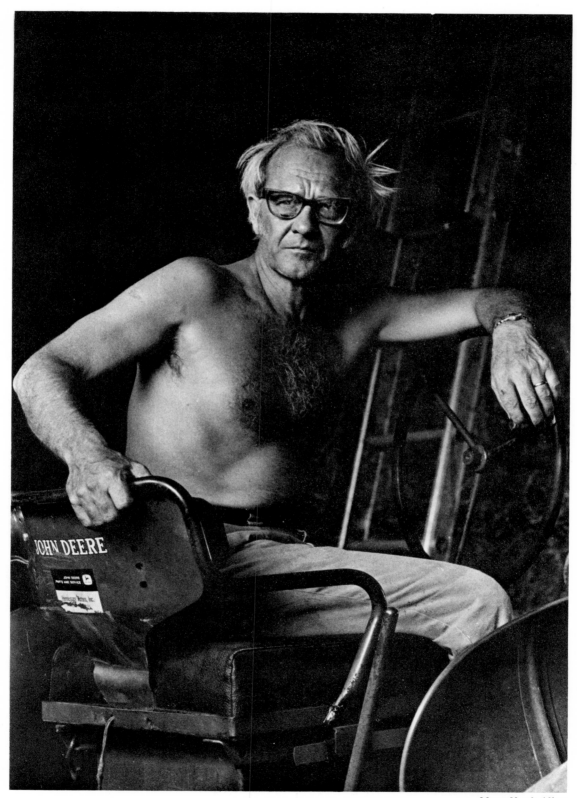

Mary North Allen

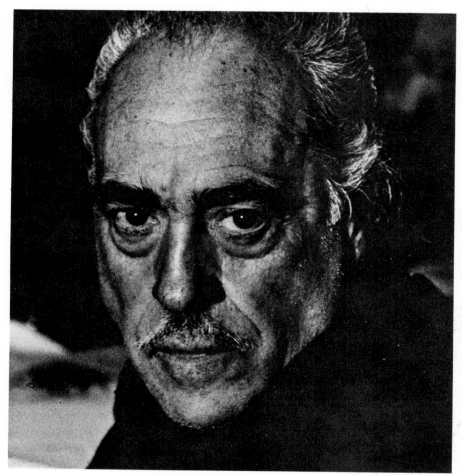

Dena

Esteban Vicente

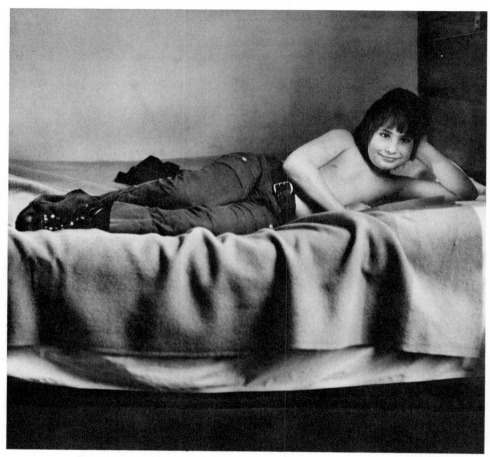

Joanne Leonard

108

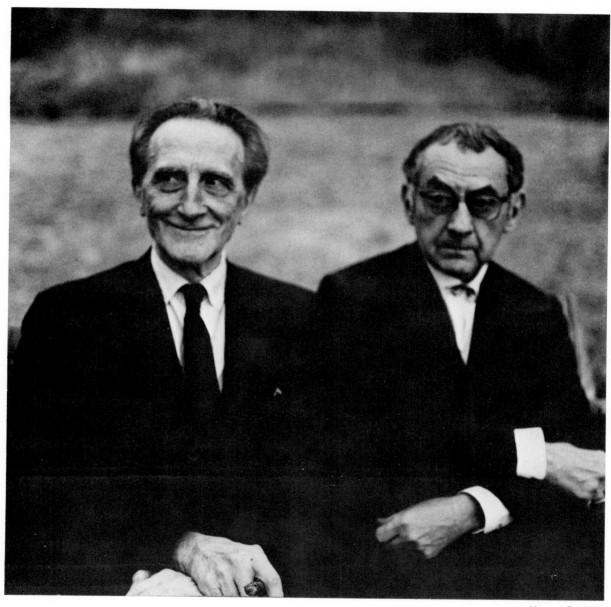

Naomi Savage

Marcel Duchamp and Man Ray

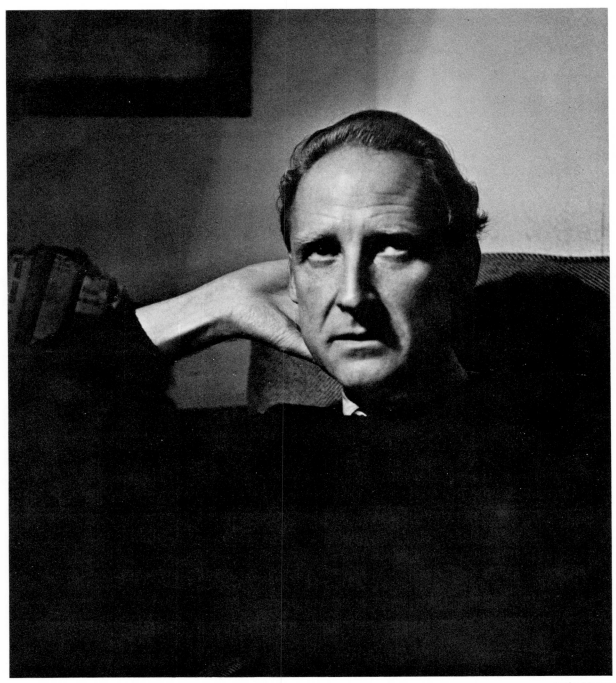

Lida Moser

Bill Brandt

Afterword

Throughout the creation of this book we were conscious of the underlying questions: Do women *really* see men? How?

It was odd to see how many women responded to our call for photos with nudes. Yet, rather than echoing the hated, depersonalizing "girlie" shots men have been taking of us for all these years, these photographs seemed to indicate a wish to please the subject — proud possessor that he is of the male genitalia.

Why, we wondered, did we receive so many portraits that lacked all but the barest intimacy or compassions. Certainly this was not due to the makers' lack of craft; most of the work was of the finest technical quality.

As we continued to review the work submitted, we discovered an underlying pattern: the unrecorded message each image contained was equally important as the one that was immediately evident. The most moving and eloquent of them seemed to portray what women wished for, rather than what they had actually experienced in their relationships with men.

Self-definition is difficult and complex. Many of us are still fighting to transcend our own fears, hopes and expectations. And until we can rise above this plateau we won't be able to rework the composition of our lives.

What these images do not explicitly express, therefore, is as essential to their content as the contact sheet is to the finished print. One must learn to read between the visual lines.

Women See Men, like its predecessor, *Women See Woman*, uses photography as a vehicle to interpret and redefine women's relationships. In common with the photographers whose work is represented here, we each have had two roles in its creation: that of commentator/communicator and that of woman. The book is the result of our response to their work both critically, as editors, and in terms of our own personal experiences, orientation, and self-image. We have woven our voices with theirs.

Taken on the simplest level, this collection presents a telling graphic statement about the place of men in society. More importantly, the photographs illuminate many of the questions, myths, and misapprehensions that still plague the delicate exchange between women and men.

Yvonne Kalmus
Rikki Ripp
Cheryl Wiesenfeld

The Photographs

Biographies

YVONNE KALMUS has worked in various facets of photography for nearly a decade. Her photographs have been seen in one-woman and group exhibits at Soho Photo Gallery and she co-juried and hung many of the group shows there. Between 1970 and 1973, she was Editorial Associate and consultant for eleven books and four exhibitions produced by The International Fund for Concerned Photography, as well as a public-relations consultant for Neikrug Galleries in New York and a Contributing Editor to *The New York Photographer* magazine. A co-editor of *Women See Woman* (Thomas Y. Crowell, 1976), Ms. Kalmus is listed in *Female Artists Past and Present*. She has reviewed books for *Popular Photography* magazine since 1973.

RIKKI RIPP has worked in a wide variety of media and has won many awards for her paintings and prints. Her recent work in film and videotape includes an archival series on artists, an independently produced tape on photographer Barbara Morgan, and *Sexual Fantasy Party*, which is included in Chicago's Videopolis circulating tape library and in the Curator's Choice Series of the Anthology Film Archives in New York. A tape about weaving in Guatemala, made in collaboration with her daughter, Wendy, was présented at the Conference on Visual Anthropology at Temple University, Pennsylvania. Working from her mid-Manhattan studio, Ms. Ripp teaches, illustrates

books, and was co-editor of *Women See Woman*. In addition to her daughter, she has two grown sons, Gary and Eric.

CHERYL WIESENFELD has been involved in the visual arts for the past six years. In that time she has worked as a picture editor, writer, photographer, curator, and researcher. She has co-edited and compiled a photographic anthology by women photographers, *Women See Woman*, and she is currently at work on a photograph-and-text book exploring the television situation comedies of the 1950s.

GERI DAVIS began her design career in the theater before switching to publishing. She has been Art Director for *Aphra*, a national women's magazine, and founder of *Many Smokes*, a national American Indian magazine, as well as Art Director at Harcourt Brace Jovanovich publishers. In 1975, one of her text designs won an award at the American Institute of Graphic Arts Learning Materials Show in New York. Ms. Davis was art director of *Women See Woman*, and maintains her own design studio.

INGRID BENGIS is the author of the widely praised book about relationships between men and women, *Combat in the Erogenous Zone* (Knopf, 1972), and the novel, *I Have Come Here to Be Alone* (Simon & Schuster, 1977).

MARY NORTH ALLEN began working in photography in 1971. A member of the photography faculty of the University of Wisconsin Extension since 1975, she is currently working on a book relating to trees. One of the first photographers to participate in the University of Wisconsin–Green Bay Open Air Art Fairs, her images have been included in such group exhibits as the Friends of Photography Members' Show, The Madison Art Center President's Invitational Show at the United Bank in Madison, and the Steenbock Center of the Wisconsin Academy of Sciences, Arts and Letters.

Most recently her work was the subject of a one-woman exhibition at the new photography gallery of the University of Wisconsin Memorial Union.

MARIETTE PATHY ALLEN has been a freelance photographer for ten years. In addition to such clients as the Lincoln Center for the Performing Arts, Inc., The Urban Design Group of the New York City Planning Commission, Cunningham and Walsh advertising agency, and the Nimbus Dance Company, she has worked for the State

Museum of New Jersey as photographer, graphic designer and researcher, and for WCAU-TV (CBS) in Philadelphia. From 1972 to 1975, Ms. Allen was Coordinator of Documentation for the New York City Department of Cultural Affairs, in charge of photographic and videotape coverage of all programs this agency sponsored or co-sponsored. Her photographs, paintings and videotapes have been exhibited at such places as the Marcel Bruyneel Gallery, The Pennsylvania Academy of Fine Arts, Crossroads Gallery, the Everson Museum and the Johnson Museum of Cornell University.

GRETCHEN BERG started out, at the age of eighteen, writing on film for many publications both here and abroad. She turned to photography in 1966. Since that time her photographs — covering everything from rock stars and the Peace Movement in the 1960s to directors, slum goddesses and kids — have appeared in books, magazines and newspapers across the country. A freelancer who combines writing with photography, she is presently a contributing editor of *Photograph* magazine.

EILEEN K. BERGER has taught dance and photography at Vanderbilt University, Tennessee State University and the Tyler School of Art. She is currently a member of the faculties of the Moore College of Art and the Philadelphia College of Art. Her photographs have been featured in exhibitions at the Museum of Contemporary Crafts in New York, the Philadelphia Museum of Art, the Philadelphia College of Art and elsewhere. Most recently, her work was the subject of a one-woman exhibit at the Stieglitz Gallery in New York City.

ANDREA J. BERNSTEIN is currently documenting humanistic architecture for the physically disabled, creating erotic photographs, and documenting the life of modern dancers. In addition, she is working on a book dealing with the myths, rituals and sexuality of the 1970s. Her photographs have been published in several local and national magazines and newspapers, including *Rolling Stone, San Francisco Magazine, Mother Jones* and the *Soho News.*

NITA BERNSTEIN has been photographing for the past four years. She studied photography at Montclair State College and the New School for

Social Research, and is currently studying with photographer Sean Kernan. Her photographs have been exhibited at Soho Gallery in New York City and are included in several private collections.

NAOMI BUSHMAN is the recipient of both a CAPS (Creative Artists Public Service) grant for photography and a National Endowment for the Arts fellowship for creative writing. Her work has been seen in both one-woman and group exhibitions, including the Midtown Y Gallery in New York City, the Hayden Gallery of MIT, the Floating Foundation of Photography, and Focus II Gallery in New York; as well as in *Celebrations* (an Aperture book), *Exposure: Ten Photographers' Work* (a CAPS publication), *Ms.* magazine, and *35MM Photography* magazine.

REBECCA COLLETTE has worked as a photographer for such newspapers as the Columbia *Missourian* and the *Lawrence County Record.* A graduate of the University of Missouri, with a Master's degree in photojournalism, she writes that "my first jobs were on small-town newspapers, where there is often a chance to photograph fascinatingly visual characters. My desire is to go wherever photography takes me."

NANCY CRAMPTON is a freelance photographer whose work often appears in publications such as *Time, Newsweek, The New York Times, The Washington Post, The Village Voice, Ms.,* and in the foreign press. In 1976 she had an exhibition at the Roko Gallery in New York City. She is currently working on a book of photographs of creative artists in America.

DENA is a freelance photographer, and teaches photography at the School of Visual Arts in New York. Originally from Finland, she has lived in the United States since 1947. Her work has appeared in many exhibitions and publications, and is represented in the collections of a number of museums.

WENDY EWALD has taught photography at the Appalachia Community Center and served as coordinator of the Mountain Photography Workshop (a part of Appalshop in Whitesburg, Kentucky) since 1975. In addition, she is project director of the NEA photographic survey grant to document the Southern Appalachian Mountains, and at

three Letcher County schools she is artist in residence for the Kentucky Arts Commission. A member of the British National Council for Photography from 1971 to 1973, she was the founder and director of the Half Moon Gallery of Photography in London. She also taught photography to children on Indian reservations in Burnt Church, New Brunswick, and Northwest River, Labrador, from 1969 to 1973 under a grant from the Polaroid Foundation. Her photographs have appeared in *Creative Camera*, and *Learning to See*, and at the Noyes Gallery of Art, the Half Moon Gallery, MIT Creative Photography Gallery and the John Ester Gallery of Abbot Academy in Andover, Massachusetts.

FLO FOX has been involved in photography for five years. Since her first one-woman exhibition at the Photographer's Gallery in London in 1975, her work has been seen at the International Center of Photography in New York City, and in *35MM Photography* magazine, *Women See Woman* and *Ecstasy: A Photographic Essay on Women's Sexual Fantasies* (a Playboy Press publication).

MARJORIE FOY is currently working on an extensive journalistic study of transvestites and female impersonators. A charter member of the Third Eye Gallery, Ms. Foy also handles the public relations for this collective organization. In addition, she is a member of the board of the Association of Artist Run Galleries (AARG). A freelance photographer, she has exhibited work at the Third Eye Gallery.

EILEEN FRIEDENEICH is an artist, freelance photographer, photographic researcher and teacher. Her work has appeared in *Exposure*, *Women See Woman*, *The Women's Yellow Pages: Original Sourcebook for Women* and *Black and White Photography: a basic manual*, as well as in such periodicals as *The New York Times Book Review*, *Harper's Weekly*, *Publisher's Weekly* and *Color Photography, 1972*. She also has been represented in group exhibitions at The First Women's Bank of New York, Harvard University, and the De Cordova Museum, and has had a one-woman show at the Panopticon Gallery.

PHYLLIS GALEMBO recently completed her M.F.A. at the University of Wisconsin in photography and intaglio printing. Her teaching experiences include photography programs for children, and she is currently teaching at the University of Wisconsin Extension (Madison). Her work has been shown in the "E Pluribus Unum" traveling exhibit and the Friends of Photography exhibit in Carmel, California.

ROZ GERSTEIN photographs to create intimate biographies of human lives. She continues to be involved in areas of information design and publishing: recently, as associate producer of a film on postpartum depression for The National Institute of Mental Health, and as executive editor of *The Women's Yellow Pages: Original Sourcebook for Women*.

DORIEN GRUNBAUM is a member of the New York City photography collective Other Eyes. Her work has been shown at the Soho Gallery, Crossroads Gallery and the Fashion Institute of Technology, all in New York City.

CHRISTINE HORNUNG is a teaching assistant and M.F.A. candidate at the University of California in Davis. She works primarily with a 4x5 view camera, and contact prints her photographs on gold-toned print-out paper. She notes, "My photographs represent an individual energy and perception, recorded on paper: my form of creative writing."

SUSAN HOUGHTALING is a New York–based photographer whose work has been seen in many exhibitions, including the Refocus National Photography exhibit, and others at the University of Iowa, the University of Ohio and elsewhere. It has appeared in publications such as *Women See Woman* and *Battered Wives* (a Glide publication), which utilized one of her photographs for its cover.

LOTTE JACOBI was one of Germany's best known and most successful portrait photographers prior to 1935, when she was forced to flee from the Nazis to the United States. In the 1950s she began working on a long series of light abstractions called "photogenics"—cameraless photographs created in the darkroom by interrupting the light from a flashlight with cellophane or paper masks to make unique images. In 1955, after twenty years of running a studio in New York, she moved to New Hampshire, where she

continues to make photographs as well as run a gallery devoted to the work of photographers and other artists. Her work has been widely exhibited and published, and is represented in the collections of such institutions as the Museum of Modern Art, the Wellesley College Museum, and the Museum Folkwang in Essen, Germany. In 1974 Ms. Jacobi received the honorary degree of Doctor of Fine Arts from the University of New Hampshire.

ELLEN FOSCUE JOHNSON, a native of North Carolina, has an M.A. in comparative literature and has worked in crafts and music. A photographer for four years, she has contributed extensively to New England publications, and has participated in exhibitions at various New England museums and galleries and had one-woman shows in 1974 and 1977. She now lives on Terrible Mountain in Vermont and is currently completing a photographic bread book.

SONIA KATCHIAN is a freelance photographer and one of the co-editors of *Women See Woman*. Formerly a staff photographer for the *New York Post*, she has worked for the Associated Press in Beirut, as well as for such publications as *Life*, *Sports Illustrated*, *Time*, *Paris-Match*, and *Der Stern*. Her areas of specialization include boxing and the Middle East.

SARDI KLEIN is currently doing freelance photography. In addition, she teaches photography to women inmates at Bedford Hills Correctional Facility and at the School of Visual Arts in New York City.

SARAH E. LEEN is presently working on a Master's degree in photojournalism at the University of Missouri–Columbia Journalism School and studying with Angus MacDougall. She plans to do her thesis project on women and insanity. Her photographs have been seen at Brady Commons Gallery and the Daniel Boone Library (a one-woman show in 1976), both in Columbia, Missouri, and at the Yellow Door Gallery in Clayton, Missouri, as well as in issues of the *Columbia Daily Tribune* and the *Columbia Missourian*. She comments that "photography is my ticket for this lifetime; it allows me to experience everything life has to offer, and there is nothing I would rather spend my life in love with."

JOANNE LEONARD's photographs have been widely published and exhibited in group and one-woman shows, at the San Francisco Museum of Art, the Wall Street Gallery, San Francisco Art Institute, the Stanford University Art Gallery and elsewhere. She is represented in the collections of the American Arts Documentation Centre of the University of Exeter in England, the San Francisco Museum of Art, and the International Museum of Photography of the George Eastman House.

SUSAN G. LLOYD is an M.F.A. candidate in graphic design and photography. She has taught photography, English, macramé and pottery in California and Oregon. Her photographs have been seen in group and one-woman exhibitions including the second and third Annual Juried Photographic Exhibitions for Oregon Photographers, at the Rogue Gallery in Medford, Oregon, the Flashlight Gallery of the University of Oregon, and at Image Point Gallery, Dotsuns Camera Center and the Eugene Public Library.

ANN MANDELBAUM has been a freelance photographer and teacher for five years. Her work has been seen both in group and one-woman shows at such galleries as Gallery 91 and the New School for Social Research, as well as in the books *Films Kids Like* and *Doing the Media*, for which she wrote a chapter. She is currently teaching photography and film animation at the College of New Rochelle, the New School for Social Research and in public and private schools in the New York area through the NEA Artists-in-the-Schools program.

VIVIENNE MARICEVIC is a past picture researcher and cartoon editor of *True* magazine. Currently she is assistant to the editorial director of *Popular Photography*.

ELIZABETH MATHESON is a photographer and editorial assistant at Duke University. Her photographs have appeared in *Latent Image*, volumes II and III, as well as in both group and one-woman exhibits at such places as the Light Factory in Charlotte, North Carolina, Garden Gallery, the Southeastern Center for Contemporary Arts, Duke University, the New Orleans Museum of Art, the Virginia Museum of Art, and the North Carolina Museum of Art.

INGE MORATH has been a freelance photojournalist for over twenty-five years. Her work has been published in most major magazines in this country and Europe, as well as in books such as *Fiesta in Pamplona, Venice Observed* (with Mary McCarthy), *In Russia* and *In The Country* (both with husband Arthur Miller), and *Bring Forth the Children* (with actor-photographer Yul Brynner). Ms. Morath's photographs have been seen in numerous exhibitions including Photokina in Cologne, the World's Fair in Montreal, the Chicago Art Institute, the Wuehrle Gallery in Vienna, the Power Center for the Performing Arts of the University of Michigan, and most recently, in a one-woman show at Neikrug Gallery in New York. She is represented in the permanent collection of the Metropolitan Museum of Art.

BARBARA MORGAN began photographing seriously in 1935. Her first book, *Martha Graham: Sixteen Dances in Photographs* (1941), established her as one of this country's outstanding innovative photographers. For many years she has contributed articles and reviews to various publications including *Aperture, Dance Magazine* and *Image*, and she is represented in the collections of such institutions as the Smithsonian Institution, the Museum of Modern Art and the International Museum of Photography of George Eastman House. Now in her seventies, she continues to photograph and frequently lectures at colleges and independent workshops.

LIDA MOSER has been a working photographer and writer since 1948. Her photographs and writings have been published in books, newspapers and periodicals including *Vogue* magazine, the Arts and Leisure section of *The New York Sunday Times, Harper's Bazaar, Time, Look, Newsweek, Theatre Arts, Parade* magazine and *Perspectives* (Quebec). In addition, her work has been seen in many exhibitions in both the United States and Canada. Ms. Moser uses both black and white and color photography for all kinds of subjects, in a variety of methods ranging from a basic approach to experimental manipulative techniques. Her book, *Fun in Photography: Special Effects and Techniques*, was published by Amphoto in 1974.

LEIGH H. MOSLEY is a freelance photographer and educator in the Washington, D.C., area. She made her first photographs for the Howard University newspaper in 1968 and became staff photographer for the National Welfare Rights Organization the following year. Beginning in 1970, Ms. Mosley taught journalism at Lorton Reformatory (a men's prison in Virginia) and designed brochures, made photos, and wrote and edited newsletters for Federal City College (now, the University of the District of Columbia). She is currently teaching journalism and photography at Quasi-Communications High School in the Washington, D.C., public school system.

DIANORA NICCOLINI is a freelance photographer whose work has been seen in many group and one-woman exhibitions including "Double Exposure" at the 209 Photo Gallery, "Women Photographers of New York" at the Interchurch Center in New York, "There Is No Female Camera" at Neikrug Gallery, "New York Eyes" at the Third Eye Gallery, and "Breadth of Vision" at the Fashion Institute of Technology. She is a founding member of the Women Photographers of New York and a member of The Third Eye Gallery Collective, the Biological Photographic Association, the International Center of Photography and the Kirlian Research Association.

STARR OCKENGA is Assistant Professor of Photography at the Massachusetts Institute of Technology. Her first book, *Mirror After Mirror*, dealing with the female experience from the vantage point of women between the ages of thirty and fifty, was published in 1975. She is currently working on a second book dealing with adolescent fantasy, which is scheduled to be published in the spring of 1978.

ELAINE O'NEIL divides her time between photographing and teaching. A Visiting Artist at the School of the Boston Museum of Fine Arts, through a Ford Faculty Enrichment Grant in 1976, she is currently a member of the art faculties of Tufts University and the School of the Museum of Fine Arts in Boston. From 1971 to 1975 Ms. O'Neil was Assistant Professor of Photography at the College of the Dayton Art Institute; she has also been an instructor of photography at Sinclair Community College in Dayton, Ohio, and an adjunct instructor of art/photography at Wright State University in Dayton. Her photographs have been seen in many exhibitions

throughout the country, including "Woman View" at the University of Iowa, the Dayton Art Institute, the Cincinnati Academy of Art, Tufts University and the Rhode Island School of Design.

SUZANNE OPTON is a freelance photographer whose work has appeared in such publications as *Esquire, Americana, Time, Yankee* and *Vermont Life*. Her work has been shown at the Neikrug Gallery, Midtown Y Gallery and the Floating Foundation for Photography—all in New York City—and at the Portland (Maine) Museum of Art. Ms. Opton was the recipient of a National Endowment for the Arts grant in 1973 and a Vermont Council on the Arts grant in 1975.

BARBARA PFEFFER is a Juilliard graduate who successfully pursued a career as a concert pianist before deciding to become a freelance photographer six years ago. Since that time, her work has appeared in most major publications, including *New York Magazine, Life, People, Viva, The New York Times Fashion Supplement, New Times, Camera 35, Popular Photography Annual* and *U.S. Camera Annual*. She has visited Israel several times on assignment for *The Washington Post* and the International Center of Photography. Most recently, her work was included in a group exhibition at Neikrug Gallery.

MARJORIE PICKENS is a freelance photographer whose work appears in many books and magazines. Four books of her photographs have been published, including *I Didn't Say a Word*. She was the recipient of a 1976 grant for photography from the America the Beautiful Fund.

SYLVIA PLACHY has been a freelance photographer for twelve years. She is currently working as a photographer and picture editor for the *Village Voice* in New York City. Her photographs have been seen in "Women by Women," a traveling group exhibit organized in 1972 by the Baldwin Street Gallery in Montreal, at the Post Manhattan Center, the Floating Foundation of Photography and the Museum of Modern Art. Eighty-one of her photographs, in book form, are part of the permanent collection of the Museum of Modern Art.

JACQUELINE POITIER has been making images since some cross-country tourist "snapshotting" turned her on to photography five years ago. Ori-

ginally from Brighton, England, and Killybegs, Ireland, she now lives in San Francisco and works primarily as photographer for a number of dance companies including the San Francisco Ballet, Dance Spectrum, Theatre Flamenco and Tandy Deal. Her work has been seen in a number of one-woman and group shows including exhibitions at the Bank of America Center and the University of California Extension Center, as well as in Minor White's book *Celebrations*. She received the first place award in the San Francisco Women Artists Show in 1974 and the second place award in "E Pluribus Unum" in 1976.

NANCY POLIN is a freelance photographer who effectively combines her background in education with her knowledge of photography. Since 1976 she has taught photography to children with severe reading problems as part of the Solomon G. Guggenheim Museum Title I Children's Program in New York. She has also been a Freedom School teacher and organizer at Toogaloo University in Jackson, Mississippi, and an art therapy group leader at St. Vincent's Hospital in New York, where she worked with psychiatric patients, using photography as a means of helping them express their problems. Her photographs have been in several group and one-woman shows at the Midtown Y Gallery in New York, Phoenix School of Design, the Portland (Maine) Museum of Art, the Baldwin Gallery in Toronto, Canada, and elsewhere, as well as in *Camera 35* magazine and *Confrontation*, which deals with the group encounter movement.

PENNY RAKOFF's photographs have been seen in several exhibitions around the country, including "Images of Women" in Portland, Maine, "The Magic Silver Show" in Murray, Kentucky, at Monroe Community College and the Rochester Institute of Technology, both in Rochester, New York, at the Union Art Gallery and the Reed Gallery in Ann Arbor, Michigan, and 831 Gallery in Birmingham, Michigan. She was graduate assistant for the M.F.A. Summer Transfer Program at R.I.T. and is included in *Young American Photographers,* Volume I.

JOYCE RAVID is a New York–based photographer. Her work has appeared in such major publications as *Vogue, Playboy, The Feminist Art Journal* and *Art News*.

CAROLINE REEVES is a photographer and photo-educator currently living in Santa Cruz, California. Her work has been seen in several exhibitions including group shows at the University of Minnesota and at Camera Work Gallery in Saratoga, California.

SELINA M. ROBERTS has been chairman and director of the Lane (Oregon) Regional Arts Council since 1976, when she coordinated a statewide Heritage Arts Festival for senior citizens. In addition, she is a member of the Coburg (Oregon) Planning Commission, serving as its vice president since 1975, and a member of the Citizens' Advisory Committee. Her photographs have been seen in such group and one-woman shows as "E Pluribus Unum" a nationwide Bicentennial exhibition, and at institutions such as the University of Oregon Museum of Art, the Old Oregon Antiques Gallery, Village Fair Gallery and Lane Community College. She is represented in the permanent collection of the Coos Art Museum in Coos Bay, Oregon.

ABBEY ROBINSON is a freelance photographer whose work encompasses portraits for publication, filmstrips, exhibits for trial evidence, photojournalism for various magazines, and slide presentations of written material. Her photographs have been seen in several group and one-woman shows including "Breadth of Vision" (International Woman's Year photography show) in New York City, "The Bus Show" (on 500 New York City buses), at Higgins Hall Gallery in Brooklyn and the New York Phoenix School of Design. She is currently a consultant to the Center for Arts Information—a program sponsored by the New York Foundation for the Arts—where she is compiling a directory of services available to individual photographers in New York State.

GAIL RUBINI was the art editor for Crunch Press in Los Angeles and an instructor of photography at the Rhode Island School of Design in Providence before becoming a member of the faculty of Columbia College in Chicago. The recipient of a Whitney Museum Program for Independent Study grant in 1974, she has shown work in one-woman and group exhibitions at the Yuma Art Center in Yung, Arizona, the Woods-Gerry Mansion in Providence, Rhode Island, and elsewhere. She is represented in the collection of the National Archives in Washington, D.C.

GAIL RUSSELL is a freelance photographer with an extensive background in fashion and print-making. She taught photography and photo-silk-screening at the State University of New York in Purchase and now conducts her own workshop classes in Darien, Connecticut. An Artist in Residence at Apeiron during 1976, she is the recipient of two grants from the Connecticut Commission on the Arts and has been represented in many exhibitions throughout the Northeastern United States. She is currently working on a book project for which she is doing both photographs and text.

SURA RUTH, presently a freelance photographer based in New York, has worked as assistant to the head of the Photographic Division of the Navy and Marine Corps Exhibit Center in Washington, D.C., and as assistant librarian and researcher for MD Publications in New York City. Her work has been seen in "Photographs of Women by Women," the traveling exhibition prepared and circulated by the Baldwin Street Gallery, Toronto, in 1972, as well as in such publications as *Mademoiselle* magazine (from which she received an Honorable Mention in their 1965 College Competition), *Popular Photography* and *U.S. Camera Annual.*

LINN SAGE was the recipient of a CAPS Fellowship in 1975. Her work has been seen in several exhibitions including "Vision and Expression" at the George Eastman House, "Images West" at the Museum of Natural History in New York and, most recently, in a one-woman show at the International Center of Photography. She is represented in the permanent collections of the International Museum of Photography of George Eastman House and the International Center of Photography.

NAOMI SAVAGE studied with Berenice Abbott at the New School for Social Research in 1943. Between 1944 and 1947 she attended Bennington College and studied art, photography and music. In the late 1940s she went to Hollywood as assistant to her uncle, Man Ray. Not long afterward her own work began to gain recognition and major exhibition. She has worked in photo-collage, with toning techniques, photoengraving, etching and silk-screen photos on canvas. Recent exhibitions of her work include "The Photographic Process as

Medium" at Rutgers University Art Gallery, "Women of Photography" at the San Francisco Museum of Art, Light and Lens, the Vassar College Art Gallery and the Hudson River Museum. She is represented in many major collections including the Museum of Modern Art and the Fogg Art Museum of Harvard University.

SUZANNE SEED has exhibited in New York at the Neikrug Gallery and the Floating Foundation of Photography, and in Chicago at the Center for Photographic Arts, the Darkroom, and in many group exhibitions. Her work is in the collections of the Chase Manhattan Bank of New York and the Exchange National Bank of Chicago, as well as in several private collections. For the past eight years she has worked as a freelance photographer for such clients as *Time*, *Life*, *Playboy*, *Fortune*, *The Chicago Sun-Times*, *The Chicago Tribune*, CBS, NBC, Standard Oil, North American Rockwell and many others. She is the author of *Saturday's Child*, a book of photo/interviews, and is now working on several new books.

MARJORIE SHOSTAK is a freelance photographer and anthropological writer. Her photographs and articles have appeared in *Dance Magazine*, *The Boston Globe*, *Horticulture Magazine*, *Harvard Magazine*, *Photovision '75*, in various books and in smaller publications.

SUELLEN SNYDER has been a freelance photographer since 1972. Her photographs have appeared in such publications as *Ms.* magazine, *Heresies*, *Fiction Magazine*, the *Columbia* and *Jewish Week*, and will be included in the forthcoming Ridge Press book *Family of Children*. A former staff photographer for City University's *College Discovery Newsletter*, she is staff photographer of the Synagogue Rescue Project, an historical preservation project for the Lower East Side of New York. Her work has been seen in exhibitions such as "Politics, Nature and Things In-Between" at the 112 Green Street Gallery, "E Pluribus Unum" Bicentennial exhibit, and "Women for Women" at the Open Mind Gallery in New York.

SHERRY SOLOMON is a freelance writer and photographer whose work has appeared in *The Feminist Art Journal*, the *New York Daily News* and *Soho Camera 2*. She taught photography at the

Stevenson School in New York from 1972 through 1973 and, last year, was assistant editor of *The Feminist Art Journal*. Her work has been seen in one-woman shows at the University of Conception in Chile and the Jefferson Market Library in New York City, as well as in such group exhibits as "Women for Women" at the Open Mind Gallery, at Modernage Discovery Gallery and Soho Gallery.

LUCIA A. SPURGEON is currently employed as an ophthalmic photographer (photographing the retina of the eye for diagnosis) in Boise, Idaho. A graduate of Ohio University, she has also been an instructor in photojournalism at Bowling Green State University.

NINA HOWELL STARR has exhibited widely in the United States and at the Photographers' Gallery in London. "To Hire," represented here, is a 1974 Brooklyn example of her documentation of contemporary roadside folk art. Her publication ranges from *Ms.* magazine and *Women See Woman* to *Art in America*. Her work is in the collections of the Metropolitan Museum of Art and the Newark Museum.

SUSAN TINKELMAN is a freelance photographer and member of 20/20, an independent association of women photographers. She has been the recipient of four Artist-in-Residence fellowships to the Cummington Community of the Arts in Massachusetts. Ms. Tinkelman's work has been included in such exhibitions as "Womanview" at the University of Iowa, and "The Bus Show," which circulated on 500 buses in New York City during 1975, as well as in publications such as *Women See Woman*, *Women's Studies*, *Broadway Boogie* and *The Little Magazine*.

KATHY TUITE is a member of the National Press Photographers' Association and the Florida Press Photographers' Association. Formerly a staff photographer for the Sarasota *Herald-Tribune* in Florida, she has been co-photography editor of the Purdue *Exponent* since 1973. Her photographs have been seen in many exhibitions including the Campus Arts to Community Grant Program exhibit sponsored by the Indiana Arts Commission with the support of the National Endowment for the Arts, "Radius-75" at the Burpee Art Museum in Rockford, Illinois, and "Final Prints," a one-woman show in Charlottesville, Virginia.

ELIZABETH TURK teaches photography at Georgia State University and the Atlanta College of Art. She is a candidate for a Master of Visual Arts Degree in photography from Georgia State University and the staff photographer for the Atlanta Urban Corps. Her photographs have been seen in several group exhibitions in the Atlanta area including the Art Workers Coalition of Atlanta Exhibition sponsored by the City of Atlanta Bureau of Cultural and International Affairs, "Georgia Women in the Arts," sponsored by the City of Atlanta, and "Doculanta" at the Peachtree Center. She is represented in the collection of the City of Atlanta.

KAREN TWEEDY-HOLMES began making portraits while studying at Columbia University. The subject of her first New York exhibition, at Exposure Gallery in 1970, was the male nude. All her work since then has been portraiture of varying kinds: animals (zoo, domestic and East African wildlife subjects) and buildings (concentrating on Midwestern Victorian houses, their facades and details, and New York City architecture). Her photographs have been exhibited across the United States, in Mexico and in Germany. Most recently they have been shown at the Carlton Gallery (diverse subjects, June 1976), and the *Popular Photography* Gallery (animal subjects, July–August 1976). A selection of her New York City photographs appears in Helen Hanff's *Apple of My Eye* (1977).

ETHEL VIRGA studied painting and design at Cooper Union as well as advanced photographic technique at the School of Visual Arts. Her work has been seen in a one-woman show at the Art Center of Queens College in New York and in several group exhibitions including "Women Photographers," "Coming of Age in America" and "Photoworks: the Third Year," all at the Midtown Y Gallery in New York, and "Collectors' Choice" at the Floating Foundation of Photography.

CATHERINE URSILLO has been a freelance photographer since 1969, when she started working for the *New York Free Press*. Her work has been published in most major magazines and has been shown in numerous exhibitions including one-woman shows at Nikon House Gallery and Soho Gallery. She has just begun work on two photographic book projects.

BERNIS VON ZUR MUEHLEN is a former teacher of English and Russian who began photographing four years ago. Her work has been seen in one-woman exhibits at the Washington Gallery of Photography, the Washington Project for the Arts, Panopticon Gallery in Boston and the Wolfe Street Gallery in Washington, D.C., as well as in such group shows as "Womansphere" in Glen Echo Park, Maryland, "Feminine Erotica" at the Washington Women's Art Center and "The Nation's Capital Photographers" at the Corcoran Gallery.

CAROL WALD is a painter, photographer and printmaker whose work has received many awards and grants including a Huntington Hartford Foundation Fellowship in 1965, grants from the Michigan State Council for the Arts in 1967, 1973 and 1974, and MacDowell Colony Foundation Fellowships in 1968 and 1971. Her work has been seen in numerous exhibitions including shows at the Raven Gallery in Detroit, a five-year retrospective at the Flint Institute of Arts, "Half-Love, Half-Hate" at the Detroit Artists' Market and "American Art at Mid-Century" in Millburn, New Jersey. She is represented in the permanent collections of the National Gallery in Washington, D.C., the Minnesota Museum of Art, Kodak Corporation and the Mountain Bell Division of I.T.T. Her first book, *Myth America, Picturing Women 1865-1945*, was published in 1975.

CAROL WEINBERG began her photographic career as a photo stylist for catalogues, advertisers and fashion studios. Her work has been published in such periodicals as *New York Magazine* and was recently the subject of a one-woman show, "Woman," at Soho Gallery in New York City.

EVA WEISS is a 1977 recipient of a CAPS grant. Her first major show, at Photopia Gallery in Philadelphia, was a three-woman exhibit with Imogen Cunningham and Joanne Frank. She has had three one-woman shows based on her work *Dos Caballos Blancos* and has been included in "Women in Art" at the Archive Gallery in Rochester, "Giraffes and Other Ladies" at the Little Gallery in Rochester, and has been published in the *Philadelphia Photo Review* and the *Rochester Democratic Chronicle*. Most recently her work was the subject of a two-woman show, at the MCC Library Gallery, Rochester.